IMAGES
of America

JEWISH COMMUNITY OF GREATER BUFFALO

IMAGES
of America

JEWISH COMMUNITY OF GREATER BUFFALO

Chana Revell Kotzin, PhD

ARCADIA
PUBLISHING

Copyright © 2013 by Chana Revell Kotzin, PhD
ISBN 978-1-4671-2006-7

Published by Arcadia Publishing
Charleston, South Carolina

Printed in the United States of America

Library of Congress Control Number: 2013931053

For all general information, please contact Arcadia Publishing:
Telephone 843-853-2070
Fax 843-853-0044
E-mail sales@arcadiapublishing.com
For customer service and orders:
Toll-Free 1-888-313-2665

Visit us on the Internet at www.arcadiapublishing.com

*For my dearest son, Noah, who is a source of joy and
wonder every day, and for my wonderful husband,
Daniel, for his unending love and support.*

CONTENTS

ACKNOWLEDGMENTS

The Jewish Buffalo Archives Project is a Jewish community-university partnership with the University Archives, State University of New York at Buffalo, under the auspices of the Bureau of Jewish Education and the Foundation for Jewish Philanthropies. Since its inception, much of the work of the Jewish Buffalo Archives Project has been supported by the generosity of funders through the Foundation for Jewish Philanthropies. Foundation funding continues with this book, which grows out of another initiative previously aided by the Foundation, the digital Jewish Buffalo Image Collection.

Partnership with the University Archives, State University of New York at Buffalo has been critical to the support and access of our collections. John Edens and Nancy Nuzzo both proved central to this relationship, and their generous help is greatly appreciated. Senior staff assistant William Offhaus at the University Archives was extremely helpful with completing extra scans. Mark Criden generously loaned materials from the Cofeld Judaic Museum. Readers Daniel Kotzin, David Gerber, Evie Weinstein, Robin Macks, and Bette Davidson made valuable comments. Rita Goldman, Ethel Melzer, Mindy Ponivas, and Jill Ginsburg at the Bureau of Jewish Education provided ongoing support. Peter Fleischmann invested significant time to look at hundreds of images. Ellen Goldstein and Jordana Halpern found additional images. Robert Deull, Rabbi Drorah Setel, Allan Werbow, Janet Gunner, Joanne Rekoon, Rabbi Alex Lazarus-Klein, and Rabbi Moshe Taub helped with their synagogue records. Dr. Douglas DeCroix, Matthew Biddle, Daniel Dilandro, Cynthia Van Ness, and Linda Reinumagi supplied essential images. Rita Weiss published our fruitful call for photographs. Don Dannecker took beautiful photographs. Kathryn McKinney maintained administrative files for each photograph and scanned numerous others, along with typing notes. Rémy Thurston and Jim Kempert at Arcadia Publishing were helpful throughout. Noah and Daniel Kotzin have been a constant support. Lastly, numerous organizations and families donated their collections for the benefit of the community and have given us all a gift in perpetuity that enables our greater understanding of Jewish history in Buffalo and Niagara Falls. Individuals who came forward to loan their photographs for this particular publication added special touches, and each has my thanks, alongside being individually identified in captions. All royalties of the author are donated to the Foundation for Jewish Philanthropies for the benefit of the Jewish Buffalo Archives Project.

INTRODUCTION

This rich pictorial history begins with Buffalo's first synagogue and traces the development of an increasingly complex and diverse Jewish community over more than 150 years. Many of the photographs were obtained from the Jewish Community Archives at the University at Buffalo, which are identified by collection title and University Archives. These are augmented by an array of community contributions.

Temple Beth El, founded in 1847 as the first Buffalo synagogue, was later joined by another orthodox synagogue, Temple Beth Zion, in 1850, which, by 1863, allied with the Reform movement. The Buffalo Jewish community was small before 1880, numbering around 1,000 with just three synagogues by 1875, and was settled for the most part around Main Street within the commercial heart of Buffalo.

Most Jews in Buffalo prior to 1880 traced their ancestry to German and Lithuanian origins. The broad German culture in Buffalo at the time was familiar and attractive to Jewish immigrants. Jewish men formed lodges, such as the B'nai B'rith Montefiore Lodge, but also participated in German music clubs as well as social clubs and other institutions. Having reached a certain level of economic attainment, Jewish men took part in broader community organizations as well; one example is Abraham Altman, a well-known banker who eventually became president of the Buffalo Club. German Jewish women created their own separate structures too, including sisterhoods and sewing circles, as well as participating in Buffalo cultural and social organizations such as the Charity Organization Society.

Violently antisemitic attacks as well as severe economic distress in Eastern Europe radically transformed the fabric of Buffalo Jewry from 1881 to 1924, as Jewish immigrants sought haven. Jewish women, many of whom were associated with Temple Beth Zion, founded many of the initial programs to aid refugees, eventually building Zion House at 456 Jefferson Avenue. This settlement house offered supplementary religious school education for children and English classes to new immigrants. It was also home to service agencies, including the forerunner to the present-day Jewish Family Service and the Jewish Federation. In 1914, social and educational programming relocated to the newly built Jewish Community Building (JCB). At 406 Jefferson Avenue, the JCB became the secular center of the William Street community.

As needs for services grew, amalgamating the existing aid groups to prevent duplication and allow coordination of fundraising and services, the Federated Jewish Charities of Buffalo was created in 1903, the forerunner to today's Jewish Federation of Greater Buffalo. Even with this union, many needs could not be addressed by funds collected by the Federated Jewish Charities alone. Self-help within the East Side became a critical transformational tool that Eastern European Jews employed themselves, creating *landsmanshaftn* (a hometown society of immigrants from the same European town or region) and mutual aid organizations.

New generations of Jews in East Buffalo acculturated through educational opportunities provided by the public school system, and in increasing numbers progressed through higher education.

For Jews who had come of age, or who were born and raised in East Buffalo, their identification as American Jews was stronger than their *landsleute* identities, which continued to comfort and anchor their parents. Younger Jews were looking beyond the confines of the William Street area; in the 1920s, they would begin the movement into the north part of the city and the West Side. War service from 1917 and the experience of America at war cemented American Jewish identities for young community members.

In 1924, the numbers of new immigrants into Buffalo and across American cities dropped precipitously following immigration legislation. Thereafter, the need for Americanization services and settlement-type services reduced, and health, cultural, and educational services for the next generation emerged, alongside services for the elderly. Social and welfare needs did not disappear but they did change. For just as the new generations of Jews in East Buffalo were moving into the middle class, joining Buffalo Jews from the earlier settled community who had already arrived there, the worldwide economic disaster that began with the stock market crash in 1929 put many dreams on hold, both in the city and beyond.

While the first two synagogues of the community had made the West Side their homes, led by Temple Beth Zion on Delaware Avenue in 1890 and Temple Beth El on Richmond Avenue in 1910, Ferry, Humboldt Parkway, and North Buffalo were emerging as areas of settlement before World War II. After the war, the Jewish Community Center, Jewish Family Service, and the Jewish Federation positioned themselves between growth to the north and northwest of the city, the West Side community, and the shrinking East Buffalo.

The growing and diverse Jewish population was no longer dominant on the East and West Sides, but was geographically widespread. Transformations in community settlement into the suburbs marked another stage, as Jews joined a general exodus of Buffalonians into the suburbs in the late 1950s. Institutions engaged in another round of organizational building and fundraising to support these relocations. Synagogues were at the forefront of this movement with entirely new congregations founded in suburban tracts. Older city-based congregations, which often underwent mergers as part of their move, followed these new congregations into the suburbs. Once the synagogues moved, other organized groups followed in later decades, such as a new branch of the Jewish Center into Getzville, now known as the Benderson Building.

City hubs remained. Temple Beth Zion retained a city site after a devastating fire completely destroyed its ornate Byzantine building at 590 Delaware Avenue. Jewish Family Service stayed too, and the first Jewish Center, now known as the Holland Building, also remained active. Completely new institutions developed in the postwar period, some of which had entirely suburban addresses while others began in the city and moved after the absorption of other entities, including Kadimah School of Buffalo (1959) and Ohr Tmimim (and its predecessors), as well as Chabad, Klein-Deutch Mikveh (Kenmore Mikveh successor), Jewish Discovery Center, Hillel, and the Holocaust Resource Center. It has been the challenge of community leaders to maintain organizations across this spread over the last 40 years.

Massive fundraising for the continuity and development of the existing community has been supported by individual philanthropists as well as by annual giving to individual organizations and Jewish Federation Annual Campaigns. Not all institutions have survived, and the Jewish community in Niagara Falls has been acutely affected by dwindling demographics.

By 2012, Jewish institutional coalescence in Getzville around a newly refurbished Jewish Community Center emerged as a multiagency approach to revitalizing the existing community. This move marks the resurgence, albeit in a different configuration, of a Jewish Community Building with most of the central agencies under one roof in a multipurpose facility that also serves as a sporting, cultural, and theater hub for the Jewish and surrounding local community. Community formation and renewal in Jewish Buffalo is a story that mirrors many other American Jewish communities with a uniquely Buffalo twist.

One

BUSINESSES

Jewish immigrants from Central Europe, part of a broader wave of Central European immigration from the 1840s to the 1870s, were the first to arrive in Buffalo alongside smaller numbers of Lithuanian and Polish Jews. Many began their working lives as peddlers but quickly transformed themselves into dry goods storefront merchants. Others entered the clothing trades, including the Warner, Desbecker, and Wile families, creating highly successful businesses. A few families entered the cigar, jewelry, and banking fields.

With the arrival of Eastern European Jews beginning in the 1880s and the growth of a Jewish neighborhood around William Street in East Buffalo, businesses arose to cater to Jewish religious needs. Kosher butchers, fruit wagons, grocery stores, bakeries, and delis filled the William Street corridor. Cigar vendors, printers, milliners, barbers, and shoe and repair shops proliferated. Close by, in the open-air Broadway Market, Jewish vendors sold a variety of produce and chickens. The familiar Jewish businesses of early Jewish immigrants still flourished, but they also expanded into new areas including metal scrap, bottle recycling, construction, plastics, and glass manufacturers.

As Buffalo burgeoned to become the eighth largest city in America in 1900, Central and Eastern European Jews were in a wide range of occupations across diverse neighborhoods. By the 1950s, a new era of Buffalo retailing, like that fashioned by L.L. Berger and Aaron Rabow at Sattler's, expanded from downtown to suburban locations. Other businesses flourished in North Buffalo, including the innovative Sample Shop. Upcoming generations of Eastern European immigrant children entered higher education at the University at Buffalo and Buffalo State College, choosing teaching, real estate, the legal profession, dentistry, medicine, pharmacy, and engineering. The commercial vibrancy of earlier immigrant generations continued into the post–World War II era even as work in the professions became the pattern of younger generations. In Suspension Bridge (later incorporated as the City of Niagara Falls), a much smaller Jewish community mirrored similar patterns of transformation from peddling to storefront success to the professions.

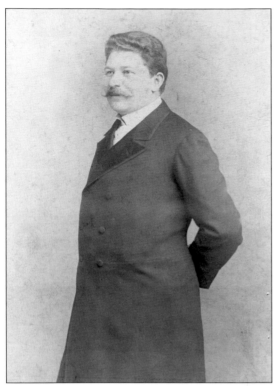

Abraham Morris Barmon from Lipno, Poland, formed a company with his brother in 1869 making hoop skirts and corsets. In 1875, he and his wife, Rachel, began a combination dry goods, millinery, and clothing store. Rachel began making ladies' housedresses for the growing ready-to-wear market. Their sons Daniel and Marcus expanded the business into the Barmon Brothers Company. (Courtesy of Selma Morris.)

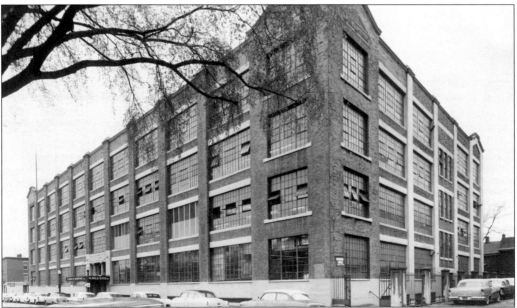

Mayer Wile, from Baden, Germany, began his pioneering Buffalo clothing business as M. Wile & Company in 1877, making mass-produced men's clothing. After numerous expansions, the company hired the architectural firm of Esenwein and Johnson to design a new factory. Built in 1924, the design improved working conditions for employees and is recognized as an example of 20th-century "daylight factory" design, recently nominated for the National Register of Historic Places. (Courtesy of Buffalo History Museum.)

Louis Maisel came to Buffalo as a teenager in 1890. He established a small picture framing company that grew into a well-known furniture store at 965–967 Broadway. Maisel's store was the first to offer installment buying. An original director of the Jewish Federation for Social Service and a treasurer of the United Jewish Appeal, he was active in the relief of Jews in Europe and a philanthropist to cultural organizations in Buffalo. Many other family members established businesses in Buffalo too. (Image copyright Western New York Heritage.)

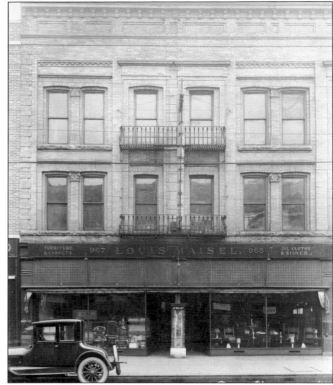

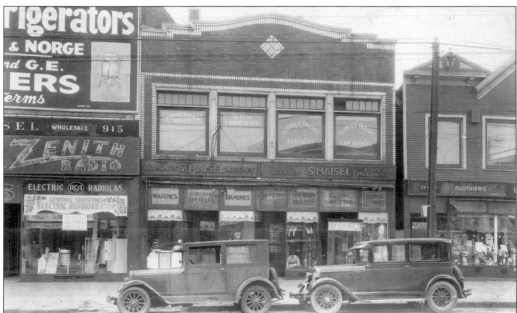

S. Maisel, located on Broadway, was owned by Sam and Sadie Maisel and was operated as a women's clothing and fur shop through the 1930s. It was also the site of Alex Maisel's jewelry, watch, and optometry business. Much later, the space combined to become Ed Maisel's furniture and appliance company. Pictured in front of the store in 1932 are the cars of Sam and Sadie Maisel. (Courtesy of Stuart W. Maisel, MD.)

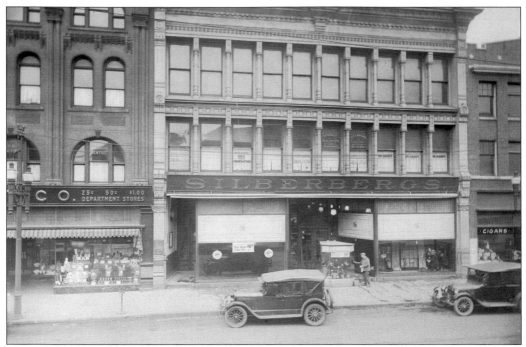

Marcus Silberberg, the founder of Silberbergs, began as a backpack peddler in the 1850s. He founded a storefront business in the village of Lewiston in 1852 and Suspension Bridge (later Niagara Falls). His sons grew the business into a large menswear store in the 1880s. The Silberbergs were active in many Niagara Falls institutions as well as the Jewish Federation of Niagara Falls. (Courtesy of Temple Beth El, Niagara Falls.)

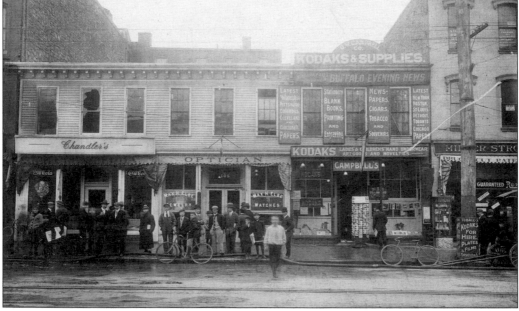

The Max H. Elbe Store, located in Niagara Falls, began in the 1880s. Elbe sold watches, jewelry, and diamonds and also provided optical services, a common combination. He was a president of Temple Beth El, Niagara Falls. (Courtesy of Niagara Falls Public Library, Niagara Falls.)

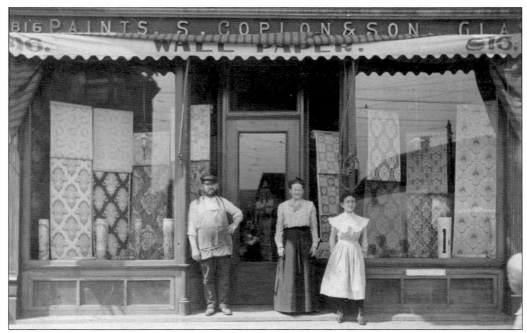

Samuel Coplon was born in Shavel, Lithuania, and emigrated with his wife, Rosa, in 1890, settling in East Buffalo. In Shavel, Rosa worked as a fishmonger, and Samuel was a glazier. In Buffalo, Samuel founded S. Coplon & Sons, a paint and glass store, which by 1900 was located at 816 Broadway. Rosa Coplon was also active in the Daughters of Israel Jewish Old Folks Home. David Coplon, their son, also worked in the business before founding his own, Walk on Rug Company. From left to right are Samuel, Rosa, and daughter Anna Coplon around 1910. (Courtesy of David and Minnie Coplon Family Collection, University Archives.)

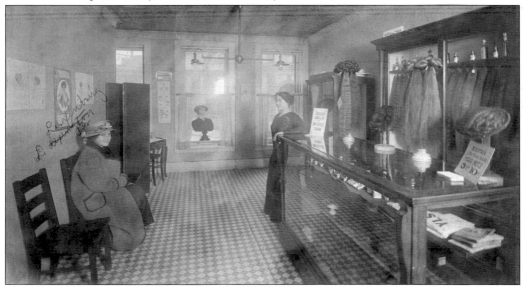

In keeping with Orthodox Jewish tradition and religious precepts of modesty, Jewish women, once married, covered their natural hair with wigs. This rare photograph, taken in 1913, is of the inside of Bernstone's Wig Shop, located at 13 East Genesee Street. It shows customer Rose Luxinburg on the left. (Courtesy of Leon R. Komm.)

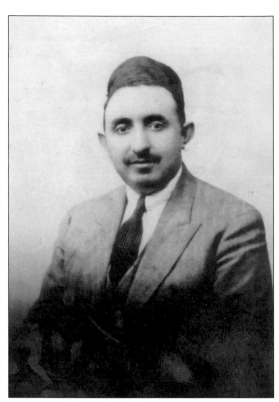

Leibisch "Louis" Silverstein was a *shochet* (ritual slaughterer) and poultry dealer from the 1920s. He was active in Achavas Achim and, in the 1940s, was a member of the National Committee of Polish Jews in America, which sought to aid Jews under Nazism. (Courtesy of JCC Collection, University Archives.)

Founded in 1922 by Jake and Ray Steinhart, Steinhart's Kosher Delicatessen and Restaurant, located at 448 William Street, promised patrons "a tasty sandwich to a tasty meal." Other delis proliferated, including Mastman's in North Buffalo. (Courtesy of Phyllis Steinhart Butin.)

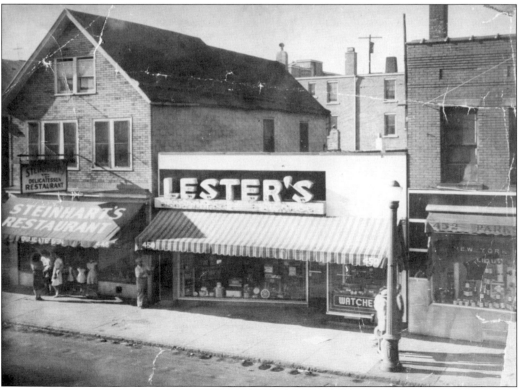

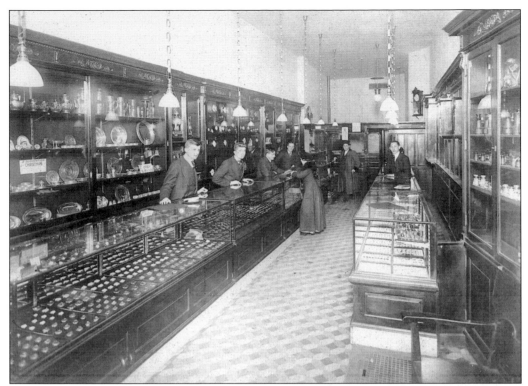

Diamond brokering and jewelry distribution and sales were popular business choices. This photograph shows Nathan Freedman working as a jeweler in Meyers Jewelry store on Main Street in 1924. Other businesses like Reeds in Niagara Falls and Buffalo and Queen City Ring Company, Saturn Ring, and Bufkor in Buffalo moved from modest to larger enterprises over time. (Courtesy of Nancy Freedman Schiller.)

Rev. (Rabbi) Isaac Manch was born in Lomza, Poland, and initially worked in Niagara Falls, moving to Buffalo to work at Congregation Ahavas Sholem on Jefferson Avenue. He later ran Manch's Judaic Shop at 169 William Street until the 1950s. His son, Dr. Joseph Manch, Buffalo public school superintendent from 1957 to 1975, took this photograph. (Courtesy of Joseph Manch Collection, University Archives.)

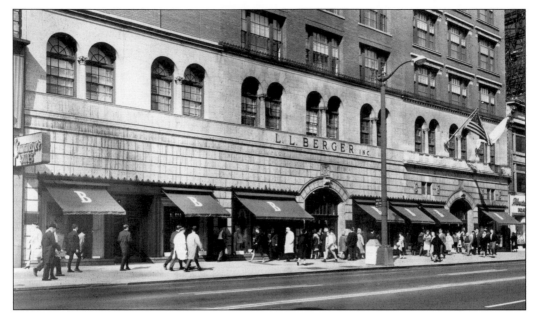

Louis L. Berger began his store in 1905 in the 500 block of Main Street as a one-story women's apparel shop. By 1960, L.L. Berger had grown to a major department store with branches in the suburbs. It featured formal wear, shoes, cosmetics, millinery, and gifts as well as signature gift wrap alongside a high level of personal service. (Courtesy of SUNY Buffalo State, Archives and Special Collections.)

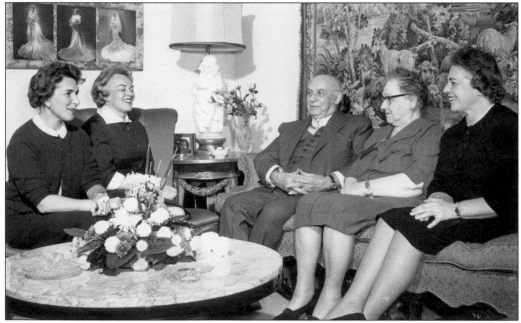

L.L. Berger Inc. was run as a family store for generations by Louis Berger, his children, their spouses, and eventually two grandsons. Louis Berger is seen here with his wife and three daughters in 1960. Berger's daughters' high-fashion bridal gowns can be seen pictured on the wall. From left to right are Roslyn Orlin, Miriam Rashman, Louis Berger, Golda Berger, and Eleanor Rieser. (Courtesy of Marcia Berger Rashman Frankel.)

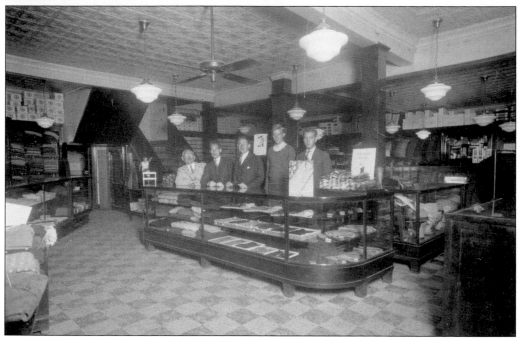

Riverside Men's Shop was run by four generations of Ehrenreich family members. It was founded in 1918 as a haberdashery, initially selling men's work clothes and men's "furnishings" by Samuel and Rose Ehrenreich. In this 1920s photograph, Samuel is on the far left. His sons Raymond and David Ehrenreich (also pictured) took over the business in the 1930s. Later, David's son Neil Ehrenreich and his daughter Betsy and son-in-law Tim Hare ran the store in a redesigned Art Deco–style building. (Courtesy of Neil Ehrenreich and Betsy Ehrenreich-Hare.)

Markel Electrics Products was a family-owned business begun in 1920 by Joseph Markel. Initially located at Clinton and Eagle Streets, the business specialized in residential lighting fixtures, later adding electric heaters and fans. Joseph Markel was highly active in the Jewish community and served as the first president of the Jewish Community Center, an outgrowth of the Jewish Community Building and Young Men's Hebrew Association. His sons and extended family members, who were also active in Jewish community organizations, later ran the business. This sales meeting took place in Buffalo in April 1953. (Courtesy of Muriel Markel Goodman.)

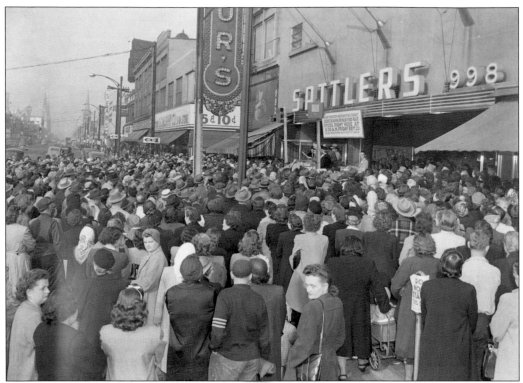

Sattler's was founded in 1889 as a one-room show store at 998 Broadway in the family home of John G. Sattler. In 1927, Aaron Rabow was hired as a women's wear buyer. He later ran the "one-stop shopping" company that was known for its "outlandish" promotional schemes, as this 1940s photograph demonstrates. He added numerous departments, including a food market, a juice bar, and a pet shop. Sattler's was a beloved Buffalo shopping experience for generations. (Courtesy of Buffalo History Museum.)

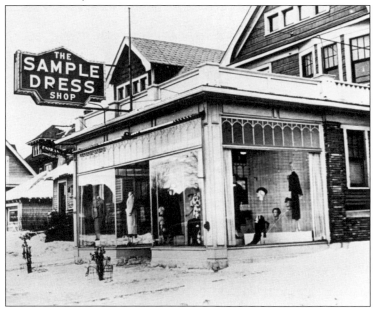

The Sample Shop was founded by Anne Bunis in 1929 in an apartment at 1631 Hertel Avenue. The first discount store in the area, Sample Shop sold salesmen's sample dresses. The shop was known for live modeling of dresses, and folding chairs were set up on the lawn so people could see the latest fashions. Anne's husband, Louis, and sons, Maer and David, all joined the business. (Courtesy of SUNY Buffalo State, Archives and Special Collections.)

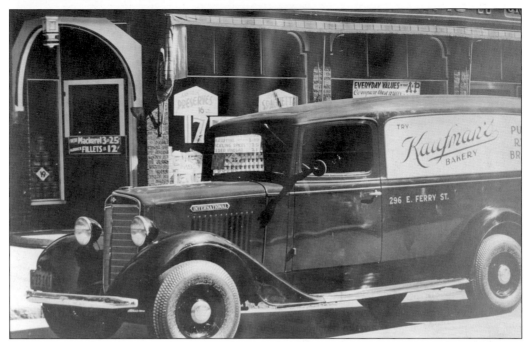

In the 1940s, Kaufman's Bakery, originally founded by Sam Kaufman, was purchased by Sam Freedman. From a small neighborhood operation, it grew into a company with over 300 employees. Kaufman's was known for the "best rye bread" and its mascot, the Jolly Baker. (Courtesy of JCC Collection, University Archives.)

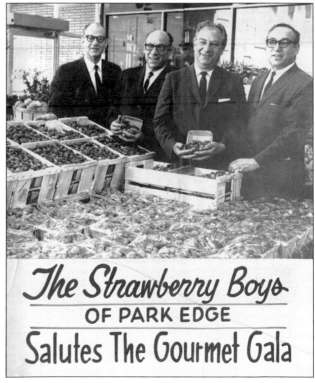

In the 1930s, Park Edge began as an open-air stand at Cazenovia Park in South Buffalo that later became a successful market store built on the same plot on McKinley Avenue. In the 1950s, Park Edge was the largest supermarket chain in the Northeast, run by brothers Harry, Samuel, Louis, and Hyman. The Benatovich Brothers also owned most of the strawberry farms on the East Coast. (Courtesy of Dr. Howard Benatovich.)

The first Jewish funeral director in Buffalo was William Sultz, who began his business in 1921 as part of the firm Cutler and Sultz. In the 1930s, Nathan Mesnekoff became a funeral director operating at Jefferson Avenue, Genesee Street, East Ferry Street, and Richmond Avenue until the iconic Delaware Park Memorial Chapel was built at 2141 Delaware Avenue in 1952. Mel Mesnekoff and grandson Jay Mesnekoff followed in the family business. (Courtesy of Jay Mesnekoff.)

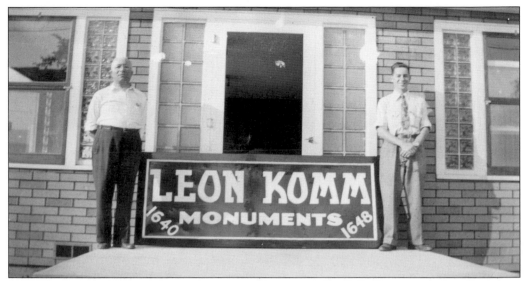

Leon Komm started a gravestone and monument business in the 1940s. Beginning a four-generation Buffalo business, he was followed by his son Parker, grandson Leon R., and most recently great-grandson Michael Komm. Now known as Leon Komm & Son Monument, his grandson, Leon R. Komm, also runs the Amherst Memorial Chapel, a Jewish funeral home. (Courtesy of Leon R. Komm.)

Sam Katz was an immigrant from Vilna, Lithuania. In 1922, he started as a peddler and then owned a grocery store on the corner of Masten Avenue and Laurel Street. After 30 years, he established Delta Wine and Liquor Store on Delaware Avenue, finally retiring at the age of 78. In his retirement, he became a devoted member of the daily minyan at Temple Shaarey Zedek. (Courtesy of Leonard A. Katz, MD.)

The Jewish community in Buffalo has produced an array of businesses, many of which became well-known names in Buffalo and beyond. Artifacts from these wide-ranging businesses are on display at the Cofeld Judaic Museum in Temple Beth Zion at 805 Delaware Avenue in Buffalo. (Courtesy of Cofeld Judaic Museum, Temple Beth Zion.)

Two

RELIGIOUS LIFE

Buffalo has a long history of diverse religious life that began with the establishment of Congregation (later Temple) Beth El in 1847, composed of Polish and Central European Jews. Differences in religious practice and place of origin produced the second synagogue, Temple Beth Zion, which became the first synagogue to ally with the Reform movement in 1863. While Beth Zion continues as a Reform synagogue in Buffalo, over time, Beth El became a Conservative congregation and, later still, merged with another synagogue, becoming Temple Beth Tzedek. Beth El and Beth Zion reveal patterns of religious life: synagogues appear, merge, revive, reformulate, or even close with changing leadership, membership base, location, and forms of worship. This occurred in Buffalo and other American Jewish communities across the decades.

This pattern of activity was especially pronounced during the building of the East Side as a Jewish neighborhood from the 1880s, where each synagogue distinguished itself by community of origin or custom of worship. Eight major Orthodox synagogues were established and often known by the streets on which they settled, but their Hebrew names revealed much about their identities. Anshe Sokolovka (People of Sokolivka, 1917) recalled links to hometown origins, while Ahavas Sholom (Lovers of Peace, 1890) and Anshe Emes (People of Truth, 1912) spoke to their founders' aspirations.

The wide variety of affiliation did not cease with the decline of the Jewish East Side; rather, it moved as transportation options increased. Also, growing Jewish affluence enabled new congregations to form on the West Side of the city, such as Beth Abraham, and in the Humboldt-Utica-Ferry section of mid-Buffalo, including Temple Beth David and the Humboldt Orthodox Center. North Buffalo developed around the same time, as synagogues like Temple Emanu-El and Anshe Zedek formed in the mid-1920s and 1930s. From the mid-1940s and onwards, however, mergers followed, which included shuls from the old East Side, midtown, and North Buffalo, often correlating with a new home in the suburbs of Getzville and Amherst. In addition, wholly new suburban congregations developed.

In Niagara Falls, in contrast, synagogue affiliation was divided between two major congregations for well over 100 years—Temple Beth El (Reform) and Temple Beth Israel (Conservative). Decisions about membership in a particular synagogue depended more on religious practice, as each synagogue absorbed newcomers from a variety of immigrant backgrounds. Temple Beth El remains the only surviving congregation in Niagara Falls.

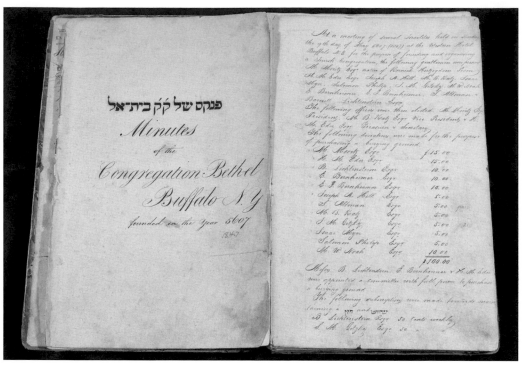

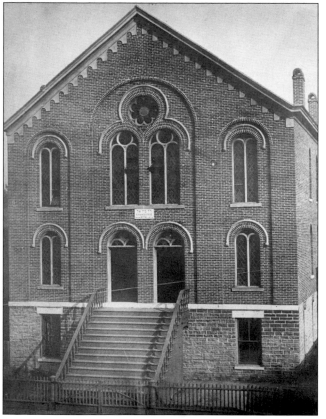

The first Jewish congregation in Buffalo, Congregation Beth-el, later Temple Beth El, was founded in 1847 with a meeting of 12 men at the Buffalo Western Hotel. The "first public worship of Israelites" took place at Passover in the Concert Hall on the southwest corner of Main and Swan Streets. Beth El began as an Orthodox shul (synagogue) and gradually moved to Conservative Judaism. (Courtesy of Temple Beth El, Buffalo Collection, University Archives.)

After a series of temporary homes and fire damage to another building, as well as a split in the congregation, Temple Beth El constructed a synagogue at 71 Elm Street in 1873 in a plot of land near North Division Street. The building was relatively large and demonstrated how quickly its peddler members had advanced economically. (Courtesy of Temple Beth El, Buffalo Collection, University Archives.)

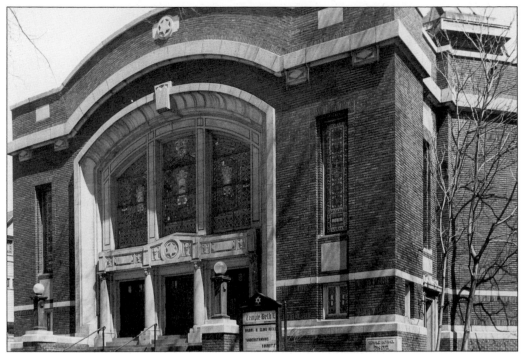

By the 1900s, Elm Street was too small, and the up-and-coming middle-class neighborhood on the West Side was selected for a new Beth El on Richmond Avenue. Dedicated in 1911, the building expressed a grand eloquence, with a dome and intricate stained-glass windows. On this premier street, it bespoke how far a section of the Buffalo Jewish community had come in such a relatively short time. (Courtesy of Temple Beth El, Buffalo Collection, University Archives.)

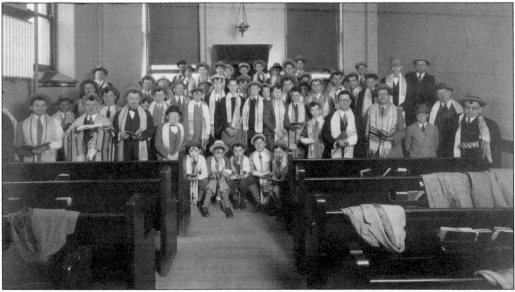

The Bar Mitzvah Brotherhood at Temple Beth El met regularly for worship and breakfast in the synagogue basement for decades. This was the opportunity for boys not just to learn their own individual portions for bar mitzvah, but also to gain a thorough grounding in the daily service. (Courtesy of Temple Beth El, Buffalo Collection, University Archives.)

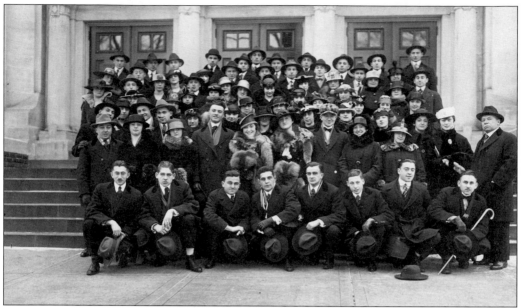

Temple Beth El's young people's groups offered an array of theatrical activities. As productions were often large and lavish, private theaters were rented and opened to the entire community. "Very Good Peggy" played at the Majestic Theater in 1917. This cast photograph was taken outside of the synagogue on Richmond Avenue and used for publicity. (Courtesy of Temple Beth El, Buffalo Collection, University Archives.)

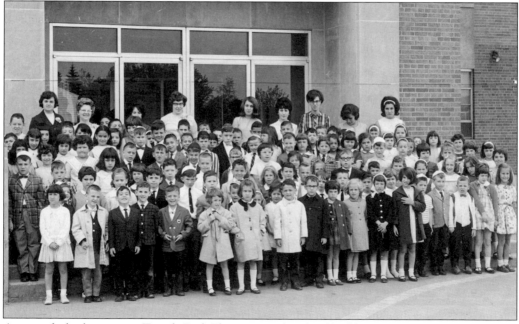

As part of suburbanization, Temple Beth El constructed a school building on Eggert Road at Sheridan Drive in the 1960s. It became "the first Conservative Jewish temple" in the Town of Tonawanda. The building was later extended to include a sanctuary when Temple Beth El left Richmond Avenue and relocated to the suburbs. This 1964 photograph of the middle and lower grades mirrors the front cover. (Courtesy of Temple Beth El, Buffalo Collection, University Archives.)

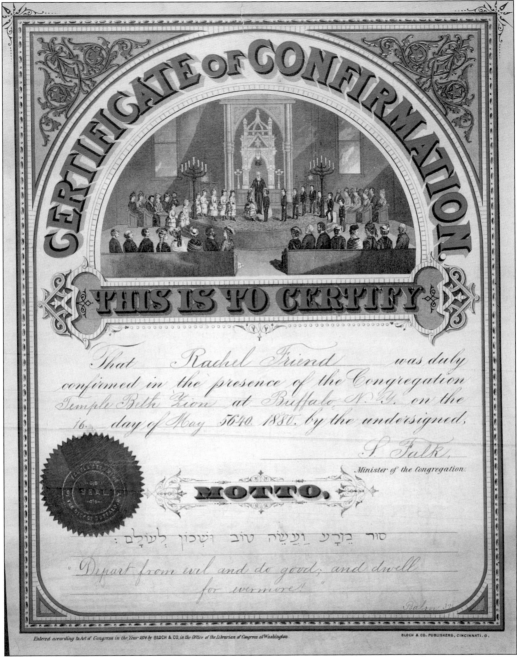

CERTIFICATE OF CONFIRMATION.

THIS IS TO CERTIFY

That *Rachel Friend* was duly confirmed in the presence of the Congregation *Temple Beth Zion* at *Buffalo, N.Y.* on the 16. day of *May 5640 1880.* by the undersigned,

S. Falk,

Minister of the Congregation.

MOTTO,

סוּר מֵרָע וַעֲשֵׂה טוֹב וּשְׁכוֹן לְעוֹלָם:

"*Depart from evil and do good; and dwell for evermore.*"

Entered according to Act of Congress in the Year 1874 by BLOCH & CO, in the Office of the Librarian of Congress at Washington. BLOCH & CO. PUBLISHERS, CINCINNATI, O.

Temple Beth Zion was founded in Buffalo in 1850 as an Orthodox synagogue. By 1863, it had allied with the Reform Judaism movement. Confirmation was a rite adopted by Jews from the 1840s as German-speaking Jewish immigrants brought ideas of a "reformed" Judaism to America. Signatory of the certificate Rabbi Samson Falk wrote the first historical article about Jews in Buffalo, "A History of the Israelites in Buffalo," published in 1876. (Courtesy of Temple Beth Zion Collection, University Archives.)

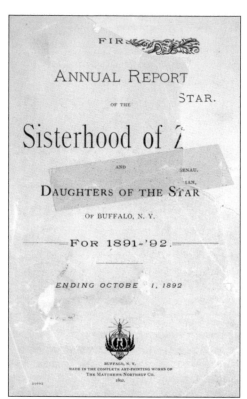

At the direction of Rabbi Israel Aaron, two women's groups within Temple Beth Zion, Daughters of the Star and the Sisterhood of Zion, banded together to create a home on Spring Street to aid with the acculturation of new Jewish immigrants from Eastern Europe. Eventually, this organization grew into Zion House, the precursor of the Jewish Community Building. (Courtesy of Temple Beth Zion Collection, University Archives.)

Temple Beth Zion's first building, the former Methodist Episcopal church on Niagara Street, was dedicated in 1865 and attended by Rabbi Isaac Wise, the leader of the Reform movement. In 1890, a Byzantine-style temple, designed by Edward A. Kent with Medina brownstone walls, pictured here, was erected at 599 Delaware Avenue. This premier thoroughfare in Buffalo indicated the confidence and prosperity temple members had attained. (Courtesy of Temple Beth Zion Collection, University Archives.)

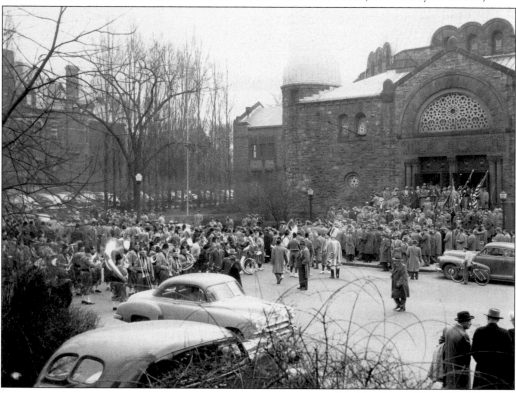

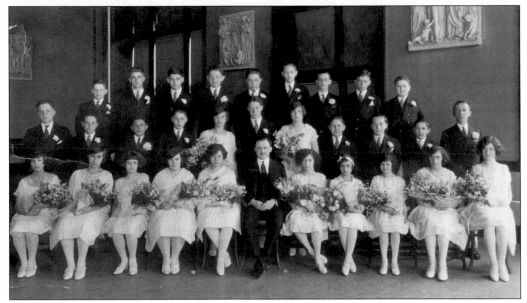

Rabbi Joseph L. Fink, who led Temple Beth Zion until 1958, was a well-respected public figure in Buffalo. His radio broadcasts on the *Humanitarian Hour* spoke to ethical topics of the day. Generations of temple members remember crowding around their radios to listen to these broadcasts. Rabbi Fink is pictured at front center with a 1920s confirmation class. (Courtesy of Marcia Berger Rashman Frankel.)

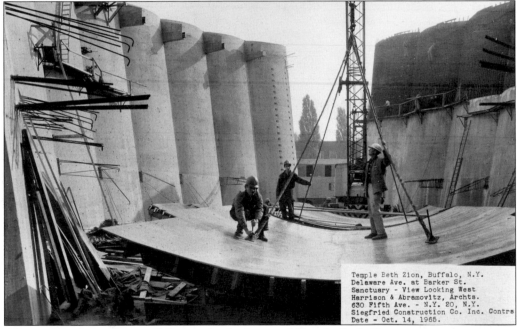

Temple Beth Zion, Buffalo, N.Y.
Delaware Ave. at Barker St.
Sanctuary - View Looking West
Harrison & Abramovitz, Archts.
630 Fifth Ave. - N.Y. 20, N.Y.
Siegfried Construction Co. Inc. Contrs
Date - Oct. 14, 1965.

After a devastating fire in 1961 completely destroyed Temple Beth Zion, a new synagogue was designed by New York architect Max Abramovitz. Erected at 805 Delaware Avenue, the building required a new method of cement pouring, and the windows needed a new method of attachment. The building was dedicated in 1967 with Rabbi Martin L. Goldberg, Rabbi Fink's successor. An iconic design, it continues as the temple's sanctuary home. (Courtesy of Temple Beth Zion Collection, University Archives.)

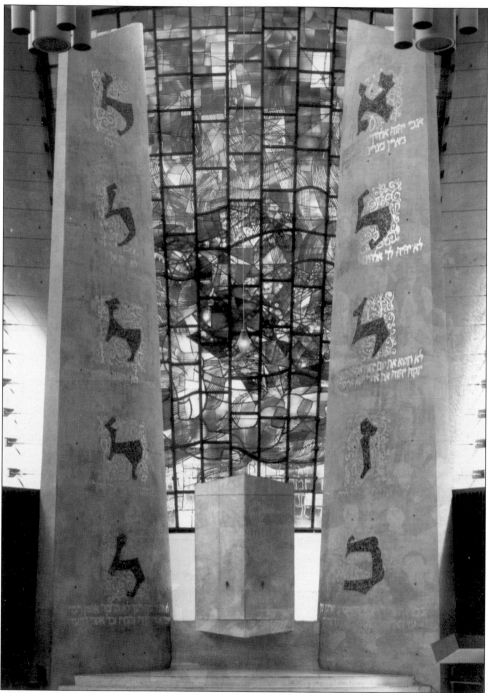

Swirling panes of iridescent blues characterize Temple Beth Zion's magnificent windows, designed by internationally acclaimed artist Ben Shahn. Thirty-foot-high commandment tablets appear on either side of the ark. Inset in each tablet are blue mosaic first letters of each commandment completed in gold leaf with Shahn's signature "dancing-style" calligraphy. In addition to religious services, festivals, and life cycle events, the sanctuary hosts numerous community-wide musical events. (Courtesy of Temple Beth Zion, photograph by Jim Bush.)

Located at 720 Ashland Avenue, Temple Beth El in Niagara Falls began as an Orthodox congregation in the village of Suspension Bridge in 1864. The congregation was officially incorporated in 1905, and dedicated the building pictured here in August 1915. The murals were painted on canvas and attached to the wall by an itinerant artist who was commissioned to create this series during the Great Depression. (Courtesy of Temple Beth El, Niagara Falls.)

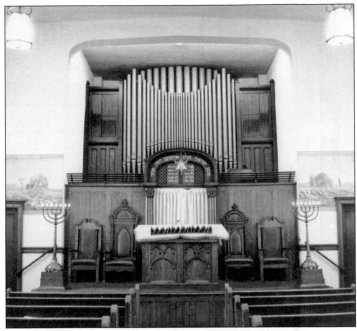

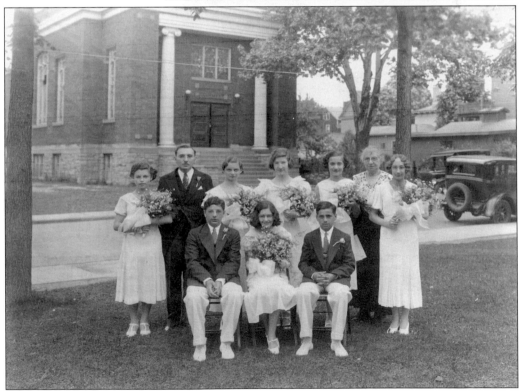

In 1926, an expansion program enabled more classrooms and, for a while, this acted as a community school, drawing children from both the Reform and Conservative Jewish traditions. Temple Beth El has the record for the oldest building in continual Jewish congregational use in Western New York. (Courtesy of Temple Beth El, Niagara Falls.)

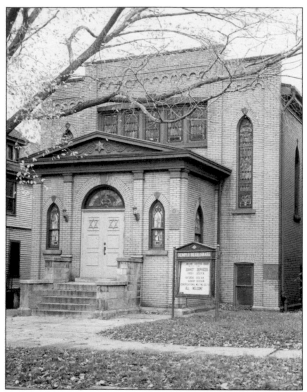

Temple Beth Israel, located on its second site at 905 College Avenue when it closed in 2012, was originally founded in 1898. The congregation first met at Mayle Hall on Third Street, then at the Crick Building at Falls and Third Streets, and in the home of Louis Wisbaum at 419 Main Street. Officially incorporated in 1905, the first synagogue building constructed in 1911, shown here, is still located at 404 Cedar Avenue, although it is no longer a synagogue. (Courtesy of Temple Beth Israel, Niagara Falls Collection, University Archives.)

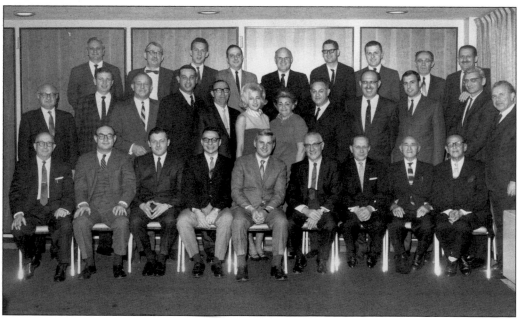

Franklin C. Wisbaum, seated in the first row on the far right, served as secretary for over 40 years. Jack A. Gellman wrote histories of Temple Beth Israel, and Rabbi Samuel I. Porrath, on the far right, served as a young rabbi in the mid-1920s and returned to serve several more times. Rabbi Porrath was also the founder of the Institute of Transportation, Travel and Tourism at Niagara University. (Courtesy of Temple Beth Israel, Niagara Falls Collection, University Archives.)

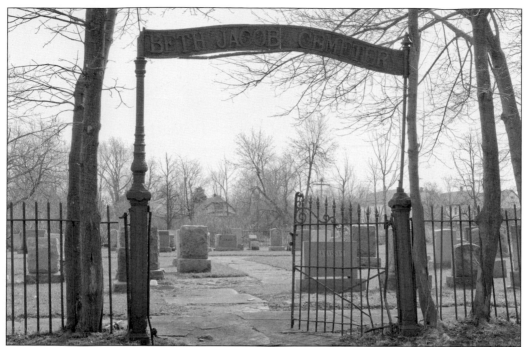

Beth Jacob synagogue, founded in 1880 and located on Walnut and Clinton Streets, was known locally as the Clinton Street Shul. It was the first synagogue formed by new immigrants from Poland. Sadly, this synagogue was demolished, and all that remains is the Beth Jacob Cemetery, dating from 1882, which is located on Doat Street in Buffalo. In 2008, the cemetery was renovated as an Eagle Scout project, led by Joshua Finkelstein and a large volunteer team. (Courtesy of Foundation for Jewish Philanthropies, photograph by Don Dannecker.)

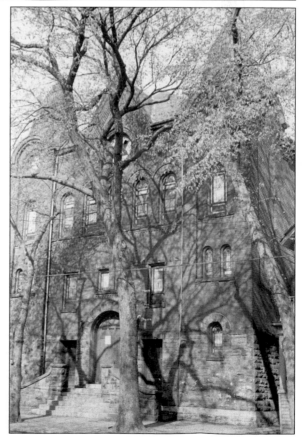

B'rith Sholem was founded in 1865 as a staunchly Orthodox European-style shul. In the 1880s and 1890s, before Eastern European Jews built their own synagogues, B'rith Sholem became the synagogue of choice. Eventually, B'rith Sholem reincorporated, moved to Pine Street, changed its worship style, and henceforth was known as the Pine Street Shul. This image is from its Pine Street location. (Courtesy of Jewish Archives of Greater Buffalo Synagogue Records Collection, University Archives.)

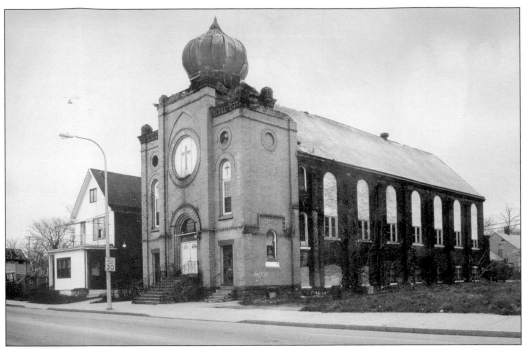

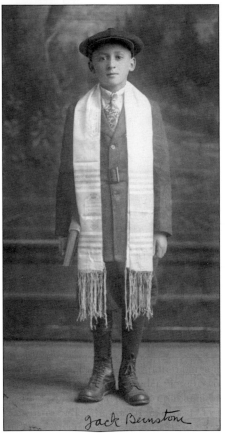

Founded by Eastern European Jews, Congregation Ahavas Sholem was also named the Jefferson Avenue Shul. Located across the road from the Jewish Community Building, the synagogue was immediately recognizable with its distinctive onion dome and yellow-brick fascia. Incorporated in 1892, it closed in 1960 and became a church, but is currently abandoned and remains the last link to a once-vibrant Buffalo Jewish East Side. (Courtesy of Cofeld Judaic Museum, photograph by Sherwin Greenberg.)

Anshe Lubavitz was founded as a Chasidic Shul in 1911. It was located at 113 Pratt Street on Buffalo's East Side and was commonly known as the Pratt Street Shul. In the 1940s, it merged with Achavas Achim to form Achavas Achim-Lubavitz and relocated to a new building on Tacoma Avenue. This c. 1910 photograph is of Jack Bernstone at Anshe Lubavitz, where his bar mitzvah was observed. (Courtesy of Leon R. Komm.)

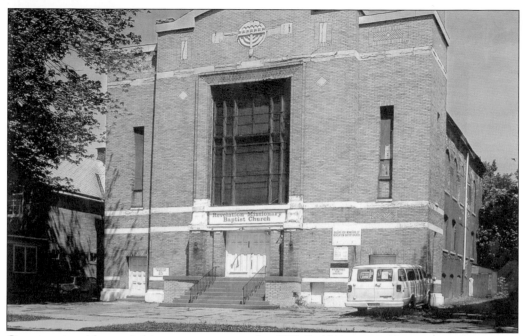

Congregation Ahavas Achim was incorporated in 1897. By 1911, it was able to secure the services of Buffalo society architect Henry Osgood Holland. The resulting modern-style building, located at 833 Fillmore Avenue, became known as the Fillmore Avenue Shul. Many of the members were from Poland. (Courtesy of Cofeld Judaic Museum, photograph by Sherwin Greenberg.)

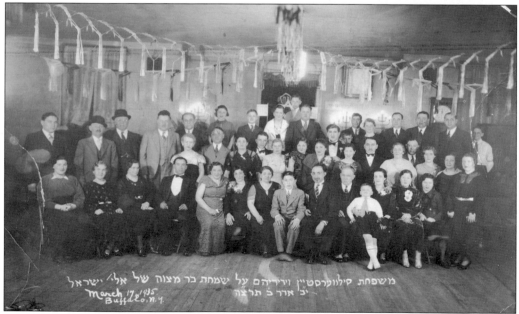

The Silversteins were longtime members of Ahavas Achim and are shown here celebrating the bar mitzvah of Isadore Silverstein in 1935. At 13 years of age, bar mitzvah was observed by Jewish boys with the chanting of a Torah (bible) portion, a segment of the Haftarah (prophets), and a speech based on the portion. The event was traditionally celebrated with family and congregants. (Courtesy of Joyce Edelman Greenspan.)

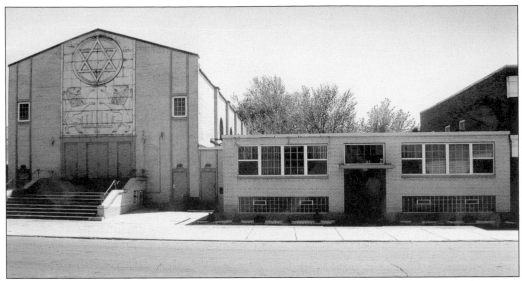

With the movement of the Jewish community away from the East Side beginning in the 1920s, many synagogues closed or merged. Ahavas Achim Lubavitz brought together two Orthodox synagogues, Ahavas Achim and Anshe Lubavitz. Their new building was erected at 345 Tacoma Avenue in North Buffalo in 1961. The Anshe Lubavitz building was demolished, and the former Ahavas Achim building became a church. (Courtesy of Cofeld Judaic Museum, photograph by Sherwin Greenberg.)

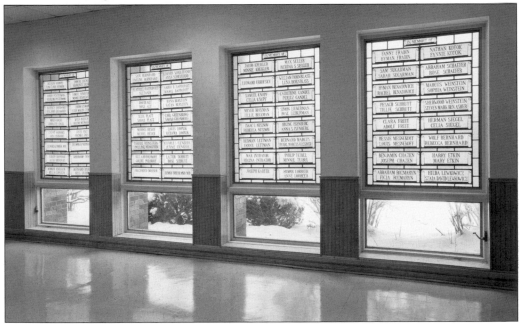

After moving to North Buffalo, Ahavas Achim Lubavitz was on the move again in the 1980s. Having built a school in suburban Williamsville on North Forest Road, the site expanded and eventually became the synagogue's new home in the suburbs. A new name was chosen, B'nai Shalom, but the stained-glass windows from Tacoma Avenue were retained and incorporated in the new building, maintaining the historic links between congregations. (Courtesy of Foundation for Jewish Philanthropies, photograph by Don Dannecker.)

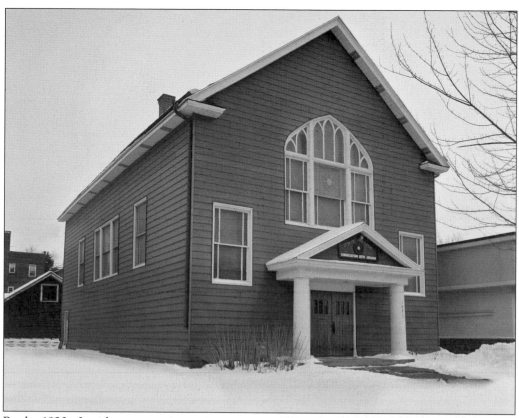

By the 1920s, Jewish congregations were forming across various sections of the city, on Humboldt Parkway, North Buffalo, and the West Side. The current Congregation Beth Abraham at 1073 Elmwood Avenue, with a newly restored sign, was a merger of parts of Beth Israel (1919) and an earlier form of Beth Abraham (1923). It was strictly Orthodox in orientation and originally located at 1045 Elmwood Avenue. (Courtesy of Foundation for Jewish Philanthropies, photograph by Don Dannecker.)

After a number of reformulations, Congregation Beth Abraham moved into the former home of Beth Israel at 1073 Elmwood Avenue and the Orthodox shul began a progression to an egalitarian Conservative outlook. The Luxemberg family was associated with the shul's founding, and active and longtime members over the decades have included the Diamond, Palanker, Sapowitch, Weinrib, and Smukler families. The congregation has recently witnessed a revival in membership with a new cantor. (Courtesy of Karen Leeds.)

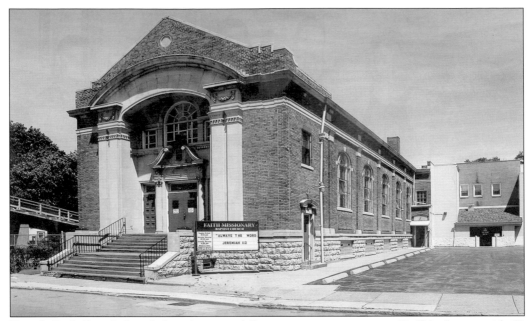

Temple Beth David, founded as the second Conservative synagogue in Buffalo, began with 50 members, meeting in a house at 652 Humboldt Parkway in 1923. By 1925, the congregation had built an imposing temple at 626 Humboldt Parkway, and the dedication ceremonies included rabbis from all existing synagogues. Rabbi C. David Matt was installed as the first rabbi in 1927. (Courtesy of Cofeld Judaic Museum, photograph by Sherwin Greenberg.)

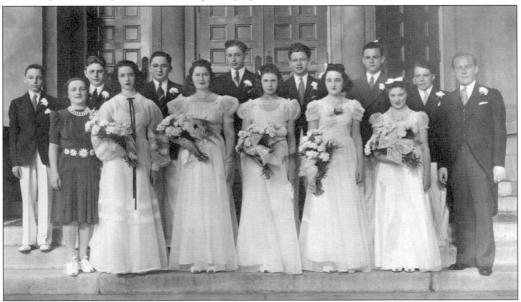

Rabbi Judah Nadich, pictured at far right, served with Temple Beth David for only a few years, but his impact was considerable, growing the congregation to over 250 members by 1940. In 1945, as the advisor on Jewish Affairs to the commander of US forces in Europe, he condemned the treatment of Jewish displaced persons. He convinced Eisenhower to enable survivors to cross into the American zone. He wrote about his experience in *Eisenhower and the Jews* (1953). Arlene Kahn is in the center. (Courtesy of Arlene Kahn Kissin.)

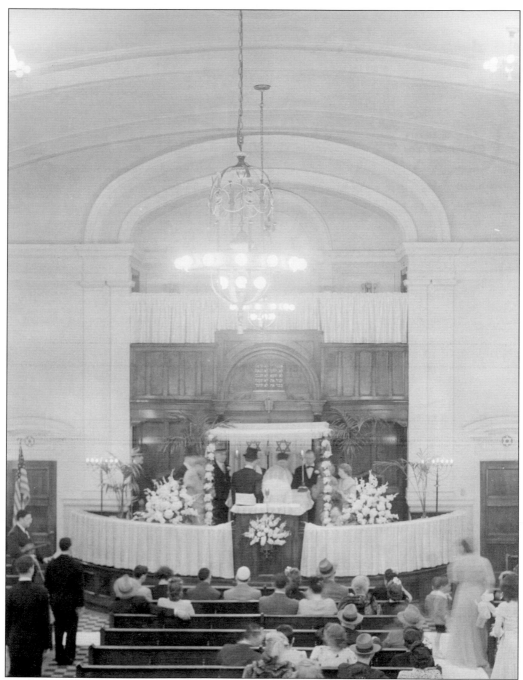

The size and grandeur of Temple Beth David's interior is captured in this wedding photograph of Evelyn Fagin to Oscar Kurz in 1947. During the 1940s, Temple Beth David had three successive rabbis including Rabbi Theodore Friedman, a scholar of Conservative Judaism; Moses Lehrman; and Sidney B. Riback. (Courtesy of Susan Freed-Oestreicher.)

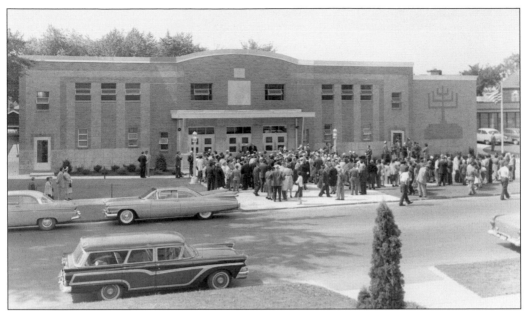

By the 1950s, Humboldt Parkway declined as the movement of Jews into the North Park area of Buffalo and the suburbs accelerated. Temple Beth David merged with Congregation Ner Israel, itself a merger of two earlier synagogues in North Buffalo, Ohav Zedek (Hungarian Orthodox) and Anshe Zedek. The new Temple Beth David Ner Israel relocated to Ner Israel's sanctuary at 500 Starin Avenue between Tacoma Avenue and Taunton Place in North Buffalo. (Courtesy of Temple Beth Tzedek.)

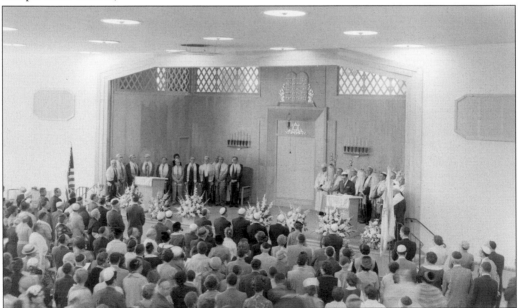

Temple Beth David Ner Israel enjoyed more than a decade at its Starin Avenue home, shown in this interior view. Unlike most abandoned synagogues, the building remains in Jewish hands as the Bais Haknesses Hagadol Lubavitch (Knesset Center). This building is run by Chabad and provides services and activities for the entire community and Buffalo State College Jewish students. (Courtesy of Temple Beth Tzedek.)

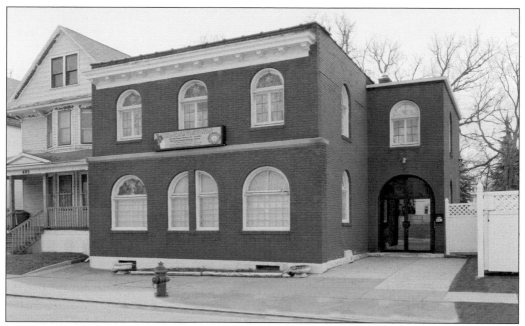

The Humboldt district of Buffalo was home to two Orthodox synagogues from the 1920s to the 1930s. Congregation Ohel Jacob, once occupying 493 East Ferry Street, pictured here, was founded in 1926 by Benjamin Meshorer, originally from Berditchev, Russia. The other synagogue, Humboldt Orthodox Center, led by Rabbi Gedaliah Kaprow from Sokolovka, Russia, was located on Glenwood Avenue. Both synagogues later lost members to the suburbs. (Courtesy of Foundation for Jewish Philanthropies, photograph by Don Dannecker.)

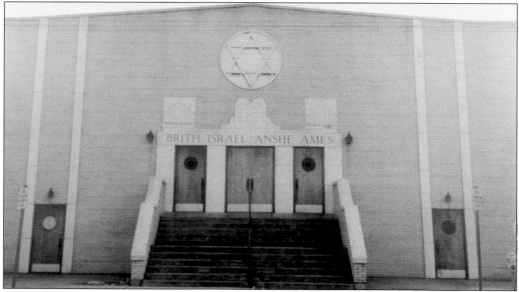

Located at 1237 Hertel Avenue and constructed in 1947, B'rith Israel Anshe Emes was a merger of two former East Side Orthodox congregations. Brith Israel was founded as the first Chassidic "Russiche shul" in 1887 at 160 Lutheran Alley. Later on, at 177 Hickory Street, it was known as "Big Hickory Shul." Anshe Emes, founded in 1912, bought its first home at 209 Hickory Street and was known as "Little Hickory." (Courtesy of Weinberg Campus, photograph by Dr. Joseph Manch.)

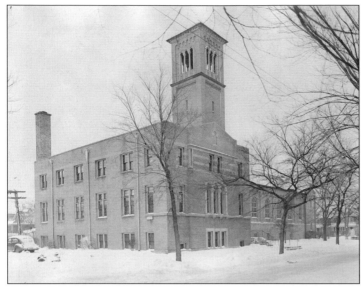

Temple Emanu-el was founded in 1924 and had a number of temporary homes along Hertel Avenue until it purchased the former North Park Baptist Church at Colvin and Tacoma Avenues in the 1930s. It was the first synagogue to be founded in the North Buffalo area that allied with Conservative Judaism. Architect Louis Greenstein remodeled the building and also added the resplendent bimah. (Courtesy of Temple Beth Tzedek.)

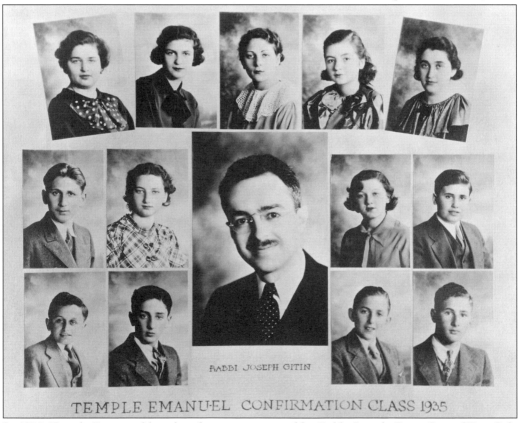

RABBI JOSEPH GITIN

TEMPLE EMANU-EL CONFIRMATION CLASS 1935

In 1930, Temple Emanu-el hired its first permanent rabbi, Rabbi Joseph Gitin. Son of East Side Rabbi Samuel Gitin (of Pine Street Shul and Anshe Emes), the younger Rabbi Gitin led the congregation into a new temple home on Colvin and Tacoma Avenues after years of temporary locations. At the opening of the newly remodeled building, the Temple Beth Zion choral group sang, and dignitaries from other synagogues were in attendance. (Courtesy of Temple Beth Tzedek.)

Rabbi Isaac Klein's magnum opus, *A Guide To Jewish Religious Practice*, continues to be used by successive generations of Conservative Jewish rabbis and their laity. He served as a military chaplain and, in 1950–1951, was appointed by President Truman to direct Jewish religious affairs in the American-occupied sector of Germany. He was appointed rabbi to Temple Emanu-el in 1953. Rabbi Klein is seated at front center. (Courtesy of Temple Beth Tzedek.)

By the mid-1960s, the movement to the suburbs was accelerating. Synagogues located in North Buffalo and Humboldt, assessing their future locations and sizes, voted overwhelmingly to relocate to the suburbs. In the late 1960s, Temple Emanu-el and Temple Beth David Ner Israel merged to form a new congregation known as Temple Shaarey Zedek and broke ground in fields, as this photograph indicates, in pastoral Amherst, New York. (Courtesy of Temple Beth Tzedek.)

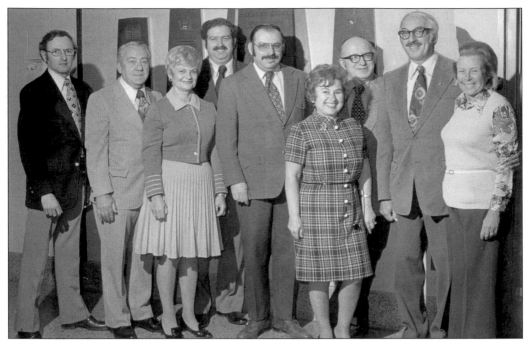

Fundraising is a part of synagogue life, whether for religious items, new building funds, or something else entirely. In addition, groups within synagogues also fundraise for other community organizations. This photograph features Dave Essrow, Herb Scheer, Warren Simon, Moritz Friedler, the Dorens, and the Coopers and their Israel Bonds Shaarey Zedek fundraising group, which was extremely active in Buffalo during the 1970s and 1980s. (Courtesy of Temple Beth Tzedek.)

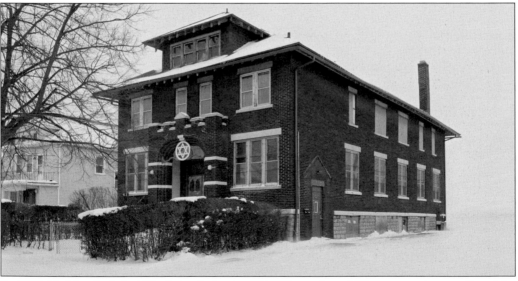

In 1952, Yeshivath Achei T'mimim Lubavitz (YATL) purchased 85 Saranac Avenue from Ner Israel. Originally founded in the 1940s, YATL subsequently became known as the Saranac Shul or Achei Tmimim. For some years, the congregation shared space with the separate Hebrew Academy of Buffalo, a Jewish day school that combined secular and religious education. Today, the Saranac Shul continues as a growing North Buffalo synagogue. (Courtesy of Foundation for Jewish Philanthropies, photograph by Don Dannecker.)

The first synagogue founded in the suburbs was Temple Sinai, formed under the leadership of Louis Bunis with 28 men and women, in 1952. This synagogue also had the distinction of being the first and only Reconstructionist synagogue in Buffalo. Initially worship began at the former Lyndale Evangelical and Reformed Church at 294 Lyndale Avenue until 1957, when a new home was built at 50 Alberta Drive. (Courtesy of Jewish Federation of Greater Buffalo Collection, University Archives.)

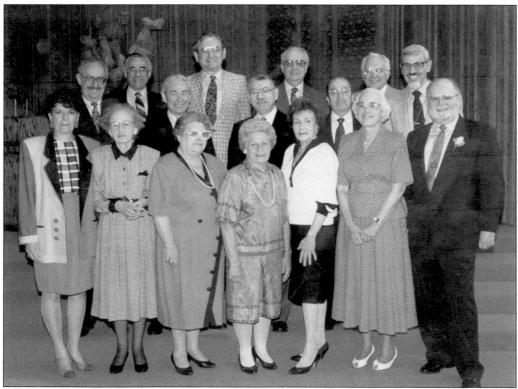

Temple Sinai rapidly developed a religious school, scout troops, sisterhood, and brotherhood, as well as a community produce garden with the proceeds given to area food banks. Under Rabbi Herzog, the longest serving rabbi, the synagogue also affiliated with the Reform movement. This image is composed of past presidents. Elliot Shapiro (with beard) is standing at center in the second row. Esther Bates (the first female president) is on the far right, standing next to Rabbi Joseph Herzog. Isadore Snitzer is standing behind her to the left, and Martin Bates stands at far right in the third row. (Courtesy of Stephanie Shapiro.)

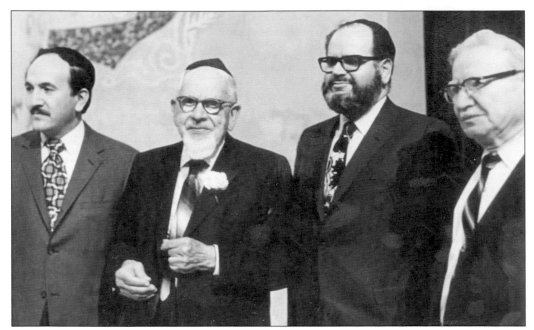

A community-wide celebration of Rabbi Mordecai Kaplan's 90th birthday occurred at Temple Beth Zion in 1971. Rabbi Kaplan's writings and teachings initiated the Reconstructionist movement in Conservative Judaism, which eventually inspired an independent Reconstructionist stream. This photograph shows, from left to right, unidentified, Rabbi Kaplan wearing a white carnation, Rabbi Herzog, and Rabbi Isaac Klein of Temple Shaarey Zedek. This public event drew hundreds of celebrants. (Courtesy of Congregation Shir Shalom.)

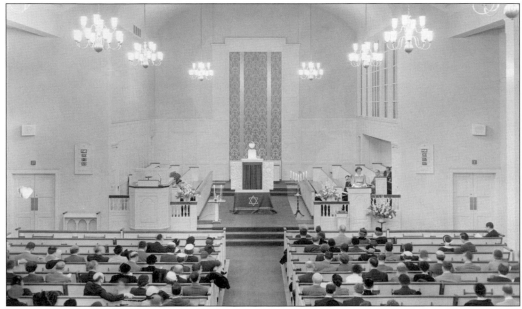

Bernard Obletz led the first organizational meeting for a new suburban Reform congregation with 100 families in 1955. These families became charter members of the "Suburban Congregation." This photograph shows their services in Amherst Community Church. Sigmund Carsell made the pine and plywood ark. (Courtesy of Congregation Shir Shalom.)

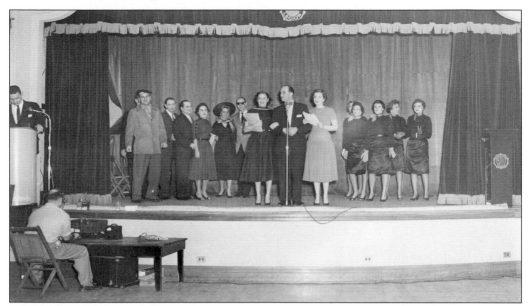

On January 4, 1956, Suburban Congregation put on the musical satire "An Ark Is Not a Boat." Written by Natalie Dautch and Esther Carsell and borrowing generously from Richard Rogers and Cole Porter, the musical traced the formation of the Congregation from the initial idea to the first constitution meeting and the formation of religious, Sunday school, and constitutional committees. Dr. Irving Vogel directed the show. (Courtesy of Congregation Shir Shalom.)

Under Rabbi Daniel Kerman, who led the congregation from 1958, the Suburban Congregation changed its name to Temple Beth Am in 1959. Throughout the 1960s and 1970s, the temple developed joint-synagogue activities, interfaith relations, and wider civic involvement, as members became involved in the campaigns to free Soviet Jewry and, later in 1988, adopted a Refusenik family. (Courtesy of Congregation Shir Shalom.)

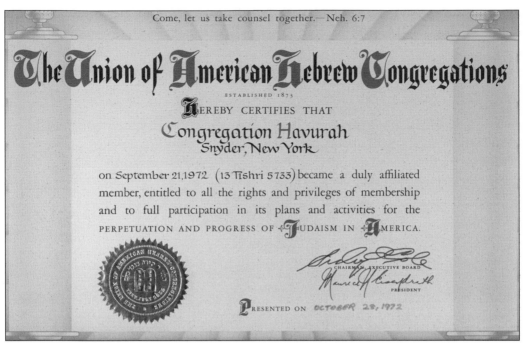

The Union of American Hebrew Congregations

ESTABLISHED 1873

HEREBY CERTIFIES THAT

Congregation Havurah
Snyder, New York

on September 21, 1972 (13 Tishri 5733) became a duly affiliated member, entitled to all the rights and privileges of membership and to full participation in its plans and activities for the PERPETUATION AND PROGRESS OF JUDAISM IN AMERICA.

CHAIRMAN, EXECUTIVE BOARD

PRESIDENT

PRESENTED ON OCTOBER 28, 1972

In the early 1970s, some members of Temple Beth Zion left to form a *havurah*, a new style of worship that relied on the group's own input. They met at each other's homes or a rented space and held an annual retreat in Chautauqua. They became a recognized affiliated member of the Reform movement in 1972. Dr. Leonard A. Katz was elected the group's first president. (Courtesy of Congregation Havurah.)

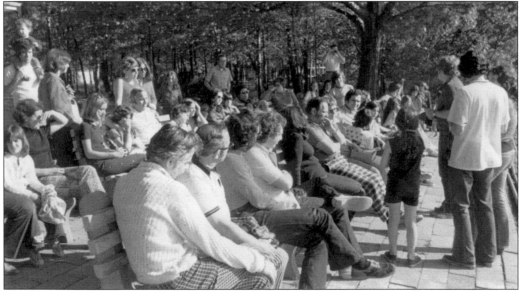

Congregation Havurah was founded on and continues to follow several major principles—the principle of freedom of thought; the acceptance of and respect for all religious beliefs within the group as a rightful part of Reform Judaism; an emphasis on family participation in congregational activities; a dynamic, honest, searching religious climate in education in which meaning is sought by young and old together; and the application of ethical principles to problems of human injustice. (Courtesy of Congregation Havurah.)

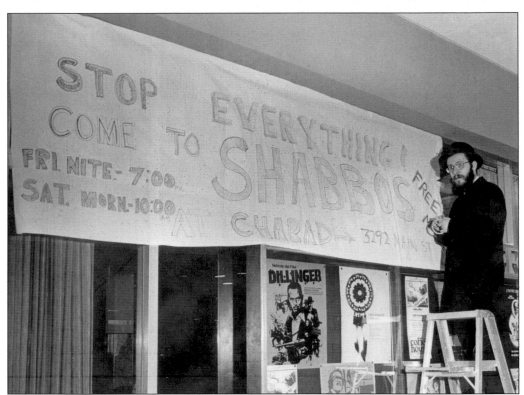

In 1971, Rabbi Nosson Gurary and his wife, Miriam, established the Chabad House at 3292 Main Street. This photograph, taken at University at Buffalo's South Campus, illustrates their outreach to university students. This tradition continues today through their sons Rabbis Avrohom and Moshe at both University at Buffalo campuses. An additional Chabad House on North Forest Road in Getzville offers a wide array of services to the entire community. (Courtesy of Rabbi Moshe Gurary.)

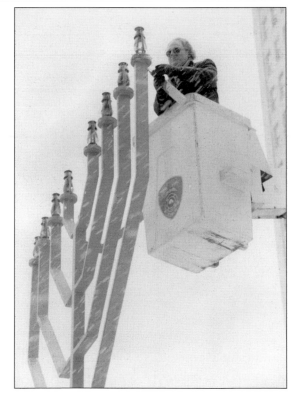

An annual tradition of Chabad House in Buffalo is the lighting of the Chanukiah (Chanukah menorah) in December. This photograph shows long-time Buffalo resident Dr. Herbert Hauptman, winner of the 1985 Nobel Prize in Chemistry, about to light the Chanukiah in Lafayette Square in downtown Buffalo. The annual ceremony has since relocated to Maple Road in Amherst, New York. (Courtesy of Rabbi Moshe Gurary.)

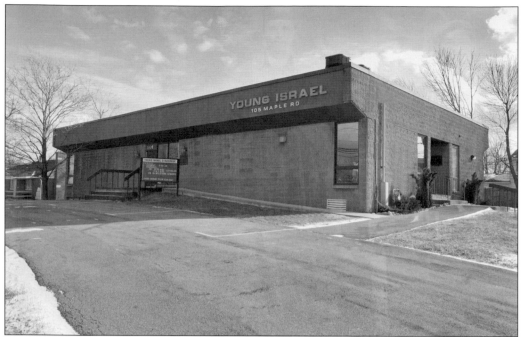

Young Israel began informally in 1973, incorporating as Young Israel of Greater Buffalo in the spring of 1974. In 1976, the first rabbi, Rabbi Kalman Winter, was hired. In 1979, the congregation built its permanent home at 105 Maple Road, pictured here. Rabbi Moshe Taub, current rabbi, led a team to successfully create an *eruv* for Amherst. (Courtesy of Foundation for Jewish Philanthropies, Don Dannecker.)

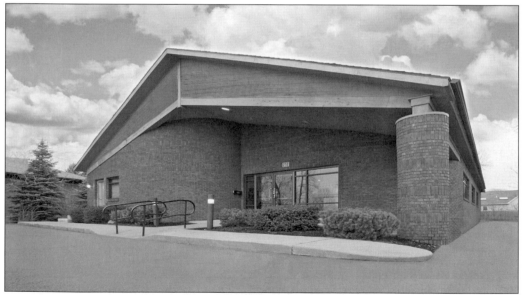

Rabbi Heschel Greenberg with Rebbetzin Lea Greenberg founded the Jewish Discovery Center. For over two decades, this center has provided family, child, and adult learning experiences for all levels of Judaic understanding. It runs special-themed Shabbat and holiday events and children's music classes, and operates a weekly Kosher café among other services. (Courtesy of Foundation for Jewish Philanthropies, photograph by Don Dannecker.)

The Klein-Deutch Mikvah at 1019 Maple Road in Amherst, known as the Buffalo Ritualarium, opened in 2000. The "Kenmore Mikvah" preceded it at 1248 Kenmore Avenue. In 1953, Rabbi Bericz Zuckerman created the plans that became a model in other cities. With the aid of Rabbi Justin Hofmann, it opened in 1957. Miriam Stern was a longtime attendant and custodian. Rabbi Heschel and Rebbetzin Lea Greenberg maintain the current Mikvah at Maple Road. (Courtesy of Foundation for Jewish Philanthropies, photograph by Don Dannecker.)

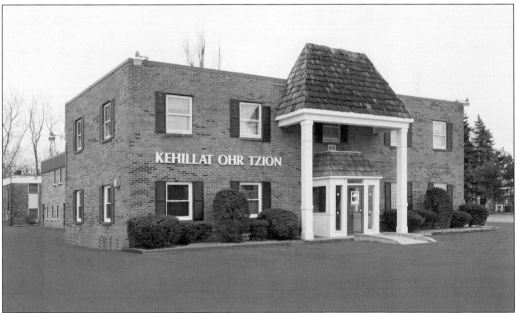

Kehillat Ohr Tzion formed as a breakaway from Congregation B'nai Shalom in 2002 over differences in religious practice. Located at 879 Hopkins Road, it is modern Orthodox in orientation, and a member of the Orthodox Union. This multigenerational synagogue recently celebrated its 10th birthday in 2012. (Courtesy of Foundation for Jewish Philanthropies, photograph by Don Dannecker.)

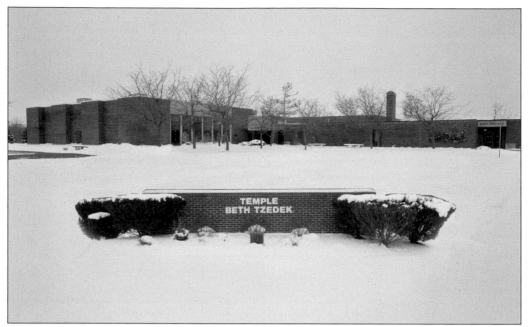

Bowing to changing demographics, in 2008, Temple Shaarey Zedek combined with Temple Beth El to form a new Conservative shul, Temple Beth Tzedek. Temple Beth El sold its building on Eggert Road, and relocated to the former Shaarey Zedek Building at 621 Getzville Road. The new synagogue remains under the wing of Conservative Judaism. (Courtesy of Foundation for Jewish Philanthropies, photograph by Don Dannecker.)

In 2012, Temple Sinai and Temple Beth Am merged and became the first dual Reconstructionist and Reform synagogue in the country. They made the former home of Temple Beth Am their new home, and the former Temple Sinai building was sold. (Courtesy of Foundation for Jewish Philanthropies, photograph by Don Dannecker.)

Three

YOUTH EDUCATION AND SOCIAL ACTIVITIES

Public schools, Jewish day schools, and religious schools offered access to an array of educational and social activities for Jewish children. Jewish day schools provided a wholly Jewish environment and a rigorous Judaic education in addition to secular studies. Jewish fraternities and sororities at public schools offered Jewish teenagers a Jewish social atmosphere within a larger secular educational environment. Temple and Jewish community youth groups and drama circles, meanwhile, offered Jewish children exposure to both American and Jewish culture. Scouting, for example, was a popular pastime for Jewish children with very clear civic dimensions. Sporting teams at the synagogues and the Jewish Community Building offered venues for Jewish children to participate in American sports within a Jewish atmosphere. Youth participated in the changing face of religious observance within synagogues and were an active part of its continuance. Such synagogue and social affiliations enabled Jewish youth to maintain familial and friendship links. College-based organizations, including Hillel and a variety of Jewish fraternities and sororities, enabled young adults to maintain and develop Jewish friendships outside of their hometown circles as well as participate in civic action in the Buffalo community.

Summer camping at both Centerland and at the Jewish Fresh Air Camp (later Camp Lakeland) offered numerous opportunities for Jewish children to socialize with other Jewish children, to learn American values, and to be exposed to a variety of streams within Judaism. While initially life at the Jewish Fresh Air Camp aimed at Americanization, it also provided the opportunity to experience an outdoor environment with access to facilities not available on the East Side. Later, the Jewish Fresh Air Camp grew into Camp Lakeland, and the emphasis shifted away from acculturation to leisure summer camping. Camp Centerland in Getzville provides day camping with the convenience of suburban access.

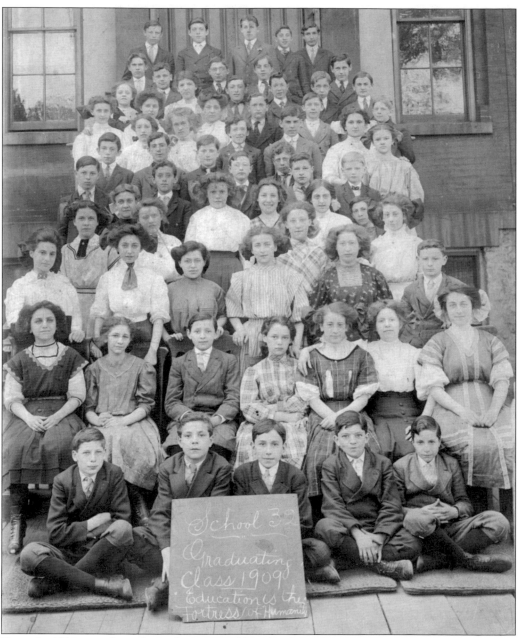

From the 1890s to at least the early 1920s, public schools on the East Side enabled Jewish children to learn in a nonsectarian environment and acculturate to American mores. Jewish immigrant children, like musical artists Jack Yellen ("Happy Days Are Here Again") and Harold Arlen ("Over the Rainbow"), gradually forged an American Jewish identity. Schools Nos. 31 and 32, heavily attended by Jewish children during this period, seemed to former students as almost "entirely" Jewish. Leaving their parents' trades of peddling, hawking, and tailoring behind, most students found themselves entering new occupations, ones their parents could never have dreamed of entering themselves. Frank Freedman's class at Public School (PS) No. 32 is seen here in 1909. He completed law school in 1918 and passed the bar in 1919, later becoming a local politician during the 1920s and 1930s. (Courtesy of Frank E. Freedman Collection, University Archives.)

Hutchinson Central High, East High School, Fosdick Masten Park High School, and Riverside High School were all high schools that Jewish youths attended from the 1900s through the 1950s. Bennett, another high school, had a very significant Jewish student body from the 1940s onwards. This image is from Fosdick Masten Park High School in 1920. At the beginning of the century through the 1920s, high schools also doubled as evening citizenship schools for immigrant parents. (Courtesy of Ellen Goldstein and Amy Goldstein.)

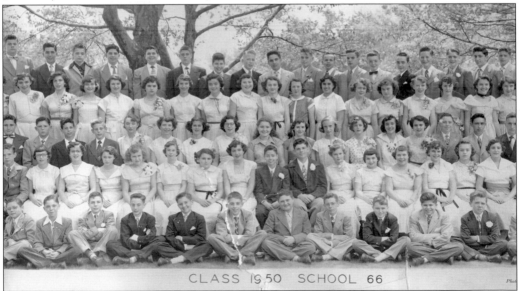

PS No. 66 (now called the North Park Academy) is located on Parkside Avenue at the intersection of Parkside Avenue, Tacoma Avenue, and North Drive. It had a high number of Jewish students during the 1940s onwards because of area temples and Jewish businesses that attracted Jews to the area. North Buffalo Jewish families formerly from the East Side moved into larger houses as they entered new professions and grew more affluent. (Courtesy of Marilyn Kaiser Sultz.)

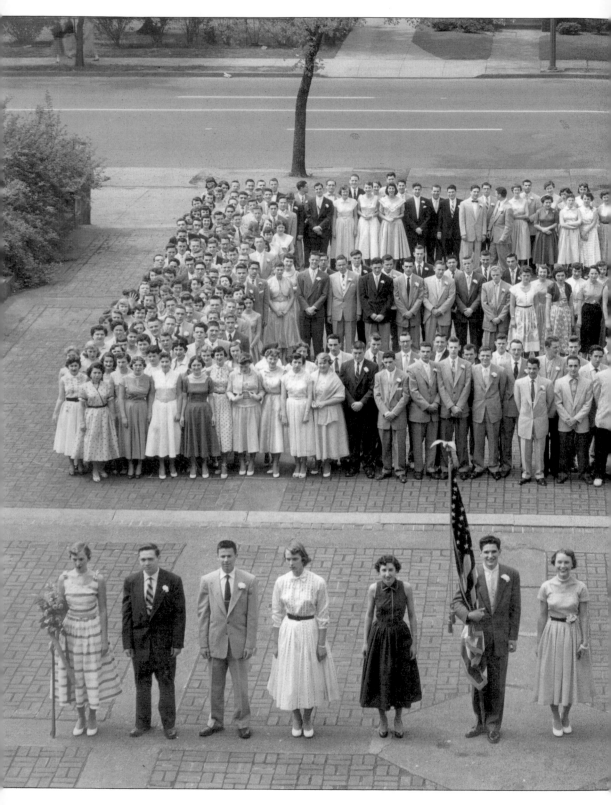

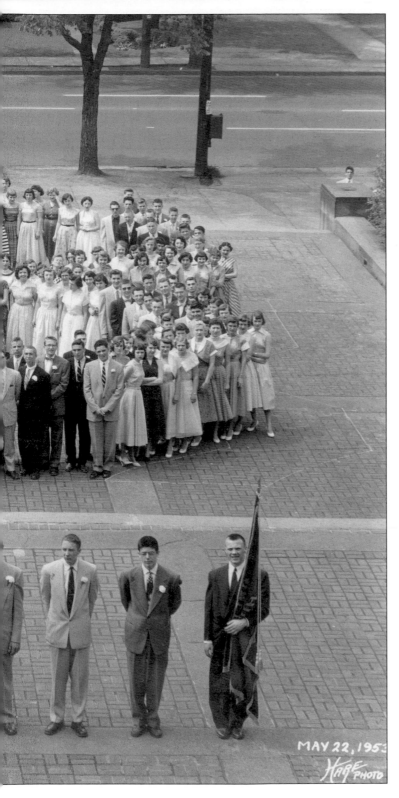

MAY 22, 1953

The high school most remembered today in Buffalo Jewish stories is Bennett High School. Located on Main Street in North Buffalo near Hertel Avenue, Bennett was a world unto itself. In addition to youth from the neighborhood, Jewish families who had moved to the suburban fringes in the 1950s sent their teenagers back into North Buffalo to study at Bennett. Apart from Hebrew instruction and various Jewish-related clubs, Jewish fraternities and sororities were an integral part of Jewish life at Bennett. Class president Leonard Katz is shown at center with the flag in this senior class graduation photograph. (Courtesy of Leonard A. Katz, MD.)

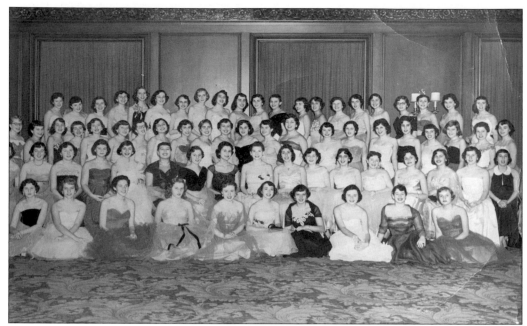

Jewish high school sororities were very popular during the 1940s and 1950s. Phi Epsilon, affectionately known as Phi-Ep, drew members almost exclusively from Bennett High School. A volunteer advisor from the Jewish Community Center on Delaware Avenue helped coordinate activities, and each year they had two social dances. This photograph taken in 1953 includes Barbara Brown, who served as president, and Joyce Edelman, vice president. (Courtesy of Joyce Edelman Greenspan.)

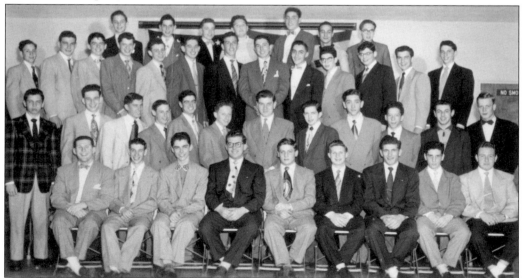

Pi Alpha Lambda, commonly known as PALS, was a fraternity of Jewish boys from Buffalo, Rochester, and Toronto. PALS included Jewish youth from East High School, but like Phi-Ep, Bennett High School members dominated the fraternity. It was one of three local Jewish fraternities; the others were ULPS (Upsilon Lambda Pi,) and STOW (Sigma Tau Omega). Each had a volunteer leader at the Jewish Community Center. This photograph was taken in the mid-1940s. (Courtesy of Leonard A. Katz, MD.)

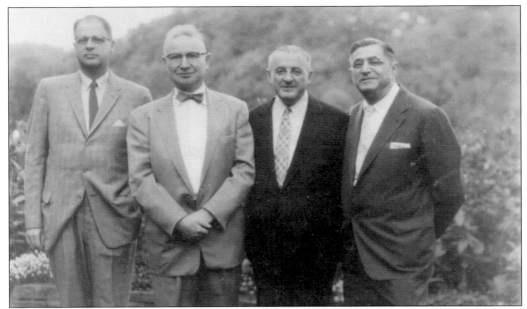

Dr. Nathan and Toby Ticktin Back formulated the idea of a comprehensive, full-day, dual-curriculum Jewish day school in 1957. Enlisting Rabbi Isaac Klein of Temple Emanu-el (second from left) and Henriette Klein to bring plans to fruition, Joseph Sapowitch (far right), furniture dealer and president of the Bureau of Jewish Education at the time) was appointed first president. Dr. Selig Adler (far left) helped with the curriculum. (Courtesy of Rabbi Isaac Klein Collection, University Archives.)

Kadimah School of Buffalo opened in September 1959 with 15 students. It utilized a variety of locations, often synagogues, as well as the Jewish Community Center. Henriette Klein is shown on the right. She acted as principal through its early years and long-term fundraiser and admissions director. Kadimah is currently located at 1085 Eggert Road, Buffalo, after a significant fundraising effort led by Dr. Sol Messinger. (Courtesy of Kadimah School of Buffalo, University Archives.)

By the end of the 1960s, Kadimah offered a school with kindergarten through sixth grade with a dual curriculum in secular and Judaic studies. After initial debates within the Jewish Federation about financial support for Kadimah, the mid-1960s saw the beginning of Federation subvention that remains in place today. In 1961, the Parent-Teacher Association instituted annual dinners that allowed parents to raise money for the school. (Courtesy of Anna Post.)

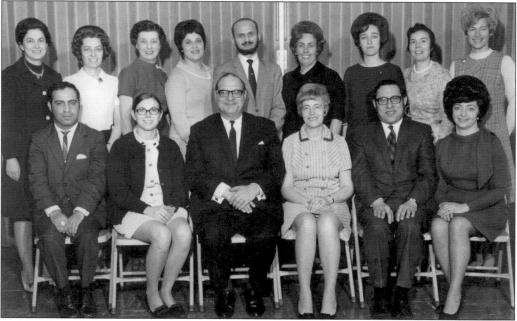

Kadimah School faculty was drawn locally and nationally from synagogue supplemental schools, public schools, and a small number of teachers from Israel. Isadore Levy (front center) was appointed principal in 1968. Anna Post (first row, third from right) was a Holocaust survivor. She eventually became a speaker for the Holocaust Resource Center in her retirement after a long career at Kadimah. (Courtesy of Anna Post.)

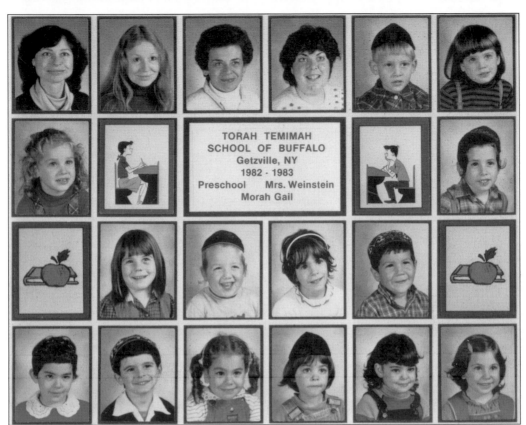

During the 1970s, Rabbi Noson Gurary founded and operated Torah Temimah Day School of Buffalo, which was affiliated with the Chabad-Lubavitch (Chabad) movement. This kindergarten-through-fifth-grade school was active through the 1990s and was initially based in the Gurary family home with Rebbetzin Miriam Gurary as the primary teacher. It later moved in the early 1990s to 500 Starin Avenue until it closed in the mid-1990s. (Courtesy of Chabad Collection, University Archives.)

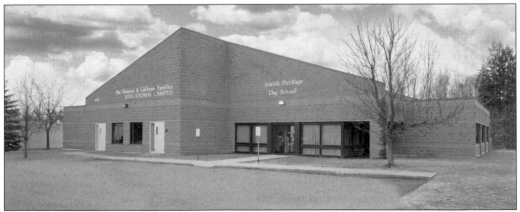

Ohr Temimim is a merger of the Jewish Heritage Day School and Torah Temimah, and is located in Amherst, New York. Rabbi Shmuel Schanowitz has served as the school's principal since 1994. An expanded campus is planned for the fall of 2013. The school is affiliated with the Chabad movement. (Courtesy of Foundation for Jewish Philanthropies, photograph by Don Dannecker.)

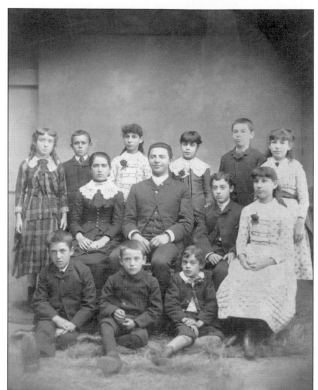

For most families, Jewish religious education was provided within a synagogue supplemental school. This approach enabled children to attend public school and gain access to English-language instruction, which was especially helpful for new immigrants. In older Jewish communities, the synagogue school began as a modest one-room affair for mixed grades, as this 1885 photograph of Temple Beth El's (Niagara Falls) Sunday school class demonstrates. (Courtesy of Temple Beth El, Niagara Falls.)

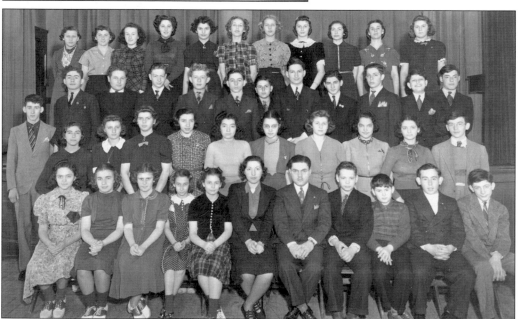

On the East Side in Buffalo, the Jewish Community Building (JCB) ran a community religious school for many decades. This photograph from 1938 shows children from the Sunshine, Snitzer, Pozarny, Organek, Komm, Tetewsky, Nemirov, and Berkoff families, among others. Children would also attend the Talmud Torah each day after school and the JCB Sunday school on the weekend. (Courtesy of Leon R. Komm.)

The Buffalo Hebrew School (the Talmud Torah) was organized in the 1890s to educate Jewish children in the "Hebrew language, Bible, History and Jewish religion." It had a strong emphasis on Hebrew and Zionism. Situated at 323 Hickory Street by 1904, it also owned another building located in the rear, which was used as a temporary Sheltering Home for Jewish transients. By 1906, it had 287 students, four teachers, and nine classes. Boys paid tuition of $1 a month and girls paid $1.50 a month. Free tuition was given to poor Jews. A branch was later added in the Fillmore Avenue neighborhood. In 1922, the school received support from the Jewish Federation, and when the building was refurbished in 1928, it also served as the first office of the Bureau of Jewish Education. Hillel Bavli, later a professor at Jewish Theological Seminary, was a teacher. (Courtesy of Jewish Federation, University Archives.)

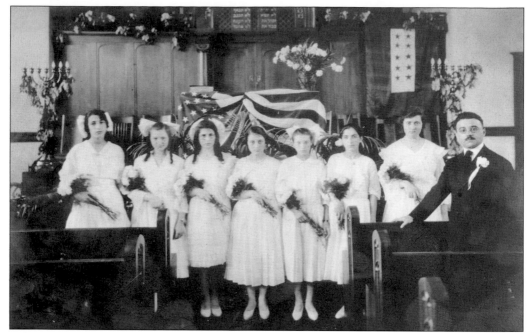

Religious rituals were part and parcel of Jewish religious life for many children. Confirmation enabled Jewish girls to learn the same curriculum as boys. In 1918, girls could not observe a bat mitzvah, as it was not introduced until 1922. However, confirmation acclimated synagogue members to greater ritual participation by girls. (Courtesy of Temple Beth El, Niagara Falls.)

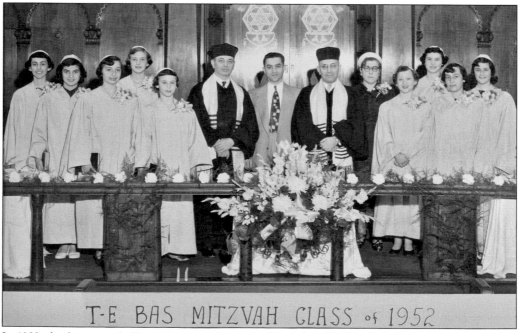

T-E BAS MITZVAH CLASS of 1952

In 1922, the first recorded bat mitzvah took place when Judith Kaplan (daughter of Rabbi Morechai Kaplan) stood in front of the bimah. For many years, bat mitzvah did not involve the same training as boys and was not equivalent to a boy's bar mitzvah, and often, girls completed their ceremonies in groups. This 1952 image is from Temple Emanu-el. (Courtesy of Temple Beth Tzedek.)

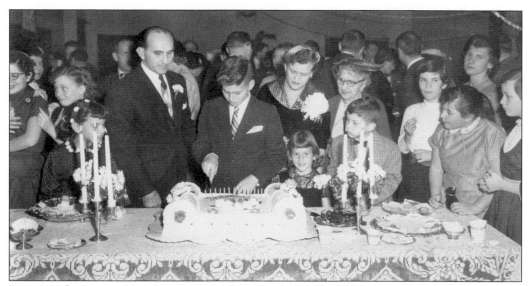

Bat mitzvah was not the only Jewish ritual change during the 20th century. Bar mitzvah changed too. Alongside bat mitzvah, public celebrations of bar mitzvah became more festive and child centered, with guests of the bar mitzvah boy, not just his family. This image shows Stuart J. Singer celebrating his bar mitzvah in 1955 at the Suburban Congregation, later renamed Temple Beth Am. (Courtesy of Congregation Shir Shalom.)

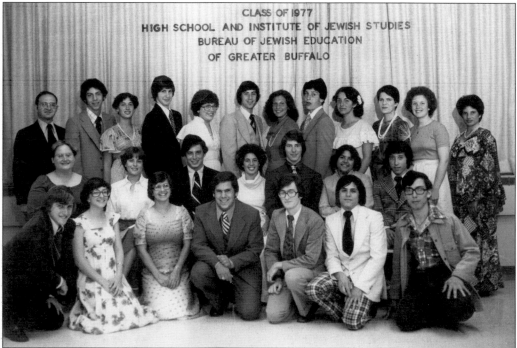

Dr. Uriah Zevi Engelman founded the High School of the Bureau of Jewish Education in the late 1920s. Dr. Engelman, a demographer at the University at Buffalo, wrote a number of statistical studies on the Jewish population of Buffalo. Dr. Samuel Paley (at far left in back row) championed Judaic studies at the University at Buffalo for over 20 years. The Institute of Jewish Thought and Heritage was established at the University at Buffalo in 2008. (Courtesy of Karla Wiseman.)

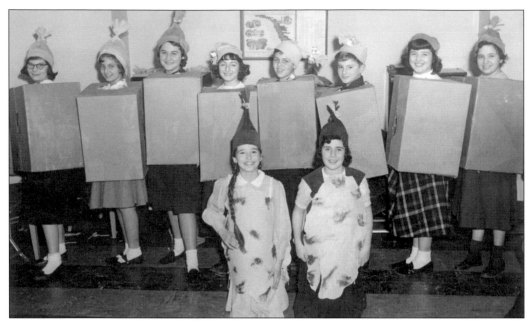

In America, a number of Jewish festivals took on greater prominence, none more so than Chanukah, the festival of lights usually celebrated in December. The Jewish Community Center on Delaware Avenue continued classes in Jewish religious education with numerous activities for Jewish youth in the 1950s. Here, the class makes themselves into a Chanukiah! (Courtesy of JCC Collection, University Archives.)

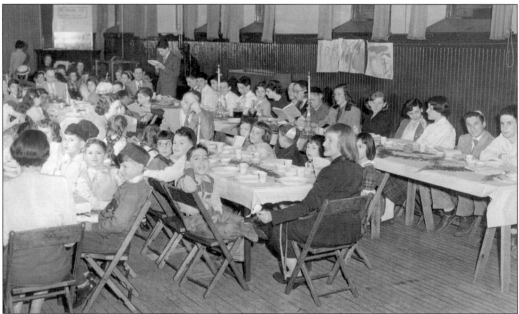

This photographs shows children participating in the model Seder. Teachers and clergy explained the composition of the Seder plate to younger children, and together the students read passages from the *hagaddah* (story) to enable familiarity with the Passover Seder. Older grades would read the entire Seder in order to master it. This photograph was taken at Beth El on Richmond Avenue in 1952. (Courtesy of Temple Beth El, Buffalo Collection, University Archives.)

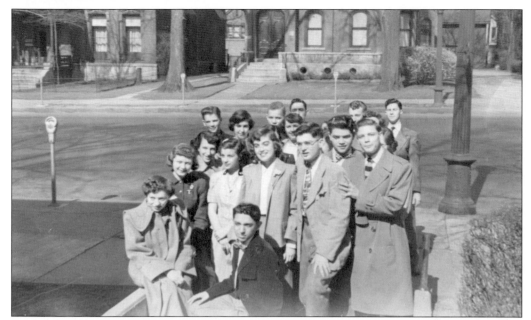

Temples had many opportunities for youth involvement on all levels, not just within Confirmation classes but in more informal social groups that enabled Jewish youth to connect with their peers and engage in social action. The Young People's Society of Temple Beth Zion (TBZ) was one example of such a social group. This photograph was taken in 1945. (Courtesy of Temple Beth Zion Collection, University Archives.)

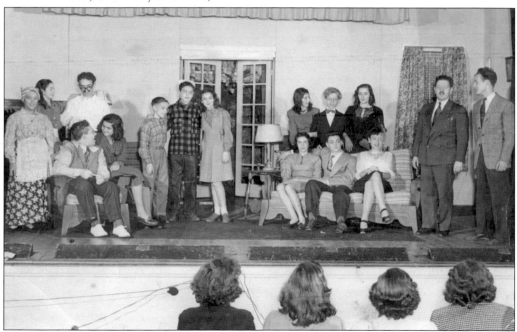

As well as informal groups, temple had numerous opportunities for other types of involvement. Many synagogues had a range of sporting teams, and basketball was particularly popular. Social dancing classes were also well attended, as was theater. This image is from a c. 1950 Temple Emanu-el Youth Theater Production. (Courtesy of Joyce Edelman Greenspan.)

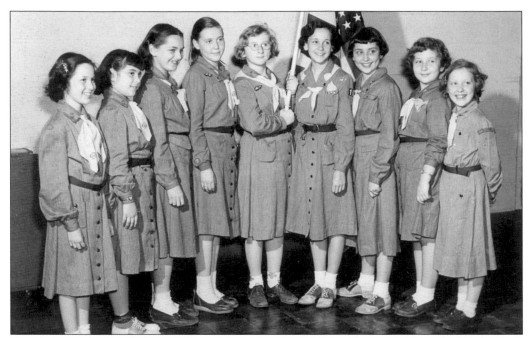

Temple Beth El was only one of the many synagogues that offered scouting for girls. While much more is known about Jewish Cub Scout and Boy Scout troops, very little material survives that documents Girl Scouting activities. This rare 1950 photograph shows a glimpse of this lost history. (Courtesy of Temple Beth El Collection, University Archives.)

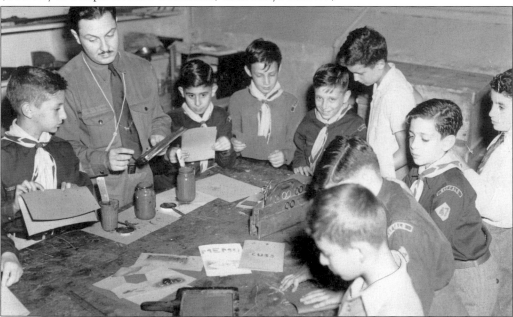

Synagogues were not the only place for Jewish Boy Scouting. A number of Boy Scout troops and Cub Scout packs operated in the JCB for a number of years. Pictured is a Cub Scout pack in 1947. Many of the members of the JCB were from modest homes, and the Scouts and Cubs provided an inexpensive source of fun and friendship. The Cub Master in this photograph is Marvin H. Garfinkel. (Courtesy of JCC Collection, University Archives.)

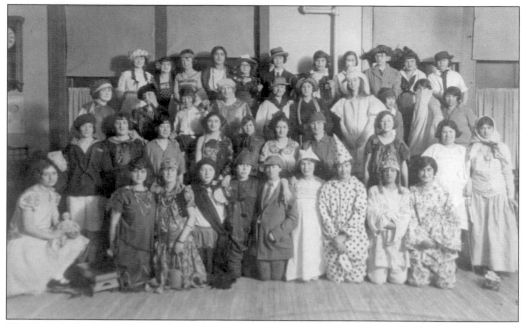

The Jewish Community Building provided activities for Jewish youth, but many wanted their own specific organization. A "Y" (Young Men's/Women's Hebrew Association) began meeting in a Walnut Street house from the 1890s. It slowly grew and eventually formed both men's and women's Ys. The combined membership was 800 in the 1920s. This photograph of the Young Women's Hebrew Association was taken at Purim in 1924. (Courtesy of Getelle Rein.)

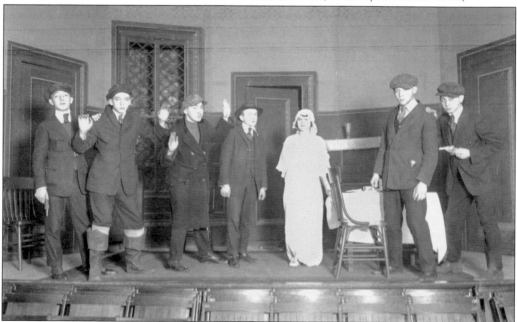

Many Jewish youth participated in drama and musicals at the Jewish Community Building, located on the East Side. This was the place from which Jack Yellen coordinated minstrel shows of the Young Men's Hebrew Association, which were hugely popular during the 1910s and 1920s. (Courtesy of JCC Collection, University Archives.)

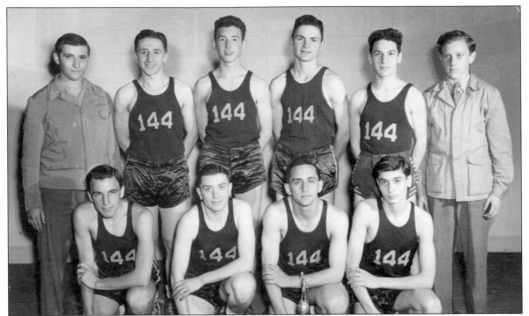

Sporting activities were a huge part of youth life for boys and girls. Basketball teams, boxing, and wrestling were popular choices for boys, and the Jewish Community Building hosted numerous teams. Max Gross sponsored the 144s. A play on his name (a gross is 144 items) became the team name! Louis Pozarny is third from the left in the second row. (Courtesy of JCC Collection, University Archives.)

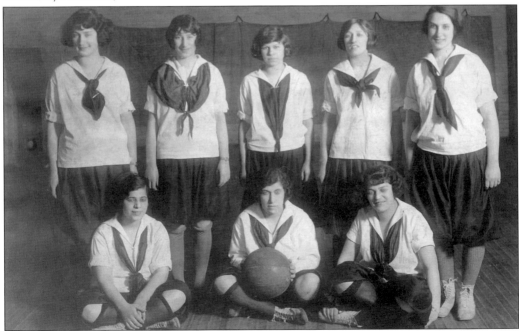

Early Jewish girls' basketball teams existed but seem to have been shorter lived. This is a rare photograph of a girls' team before the 1920s. It was taken at the Jewish Community Building on Jefferson Avenue. More popular and longer lasting were girls' fencing teams; however, images of those teams are even rarer. (Courtesy of JCC Collection, University Archives.)

The map in this image contains the following labels:

CONTINENT OF CAMPLAND

FORESTS OF REST
DORMITORYVILLE population 150
MTS. OF FRESH AIR
RIVER OF MILK
POOLS OF CLEANLINESS
HIKE'S PEAK
BASKETBALL CITY
RIVER OF MILK
PLAINS OF NATURE STUDY
FIELDS OF WHOLESOME FOOD
Libraryland
GULF OF SWIMMING
BAY OF MARSHMALLOW ROAST
FOREST OF HANDICRAFT
PEAK OF FINE LIVING

THE magic of your gold will buy their tickets to the Fairy Continent of Campland. You know the charm that will take undernourished, cheerless, little folks out of squalid, over-crowded homes and send them on a fairy journey that will bring strength to their bodies, joy to their hearts, and inspiration to their minds. Let them travel through the Land of Health, climb the Mountains of Fresh Air, sail down the River of Pure Milk that crosses the Field of Wholesome Food. Let them sleep in the Forest of Rest, bathe in the Pools of Cleanliness and stretch their legs on the Plains of Exercise. Send them to the Land of Happiness where they can glimpse the Home of Fine Living where men and women uphold the ideals of honor, self-sacrifice, and good-citizenship. Your money is the magic wand. Are you the Good Fairy of Giving or the Evil Spirit of Selfishness?

Our quota 1930—$15,000.

The Jewish Fresh Air Camp was founded in 1910 and was run under the auspices of the Young Women's Jewish Benevolent Society. A more formal Fresh Air Camp was established in Angola, New York, in 1914 with a donation of land by the Eli David Hofeller family. Inspired by social welfare, the philosophy of the camp was to "get poor children off the hot city streets and into the country for two weeks." (Courtesy of JCC Collection, University Archives.)

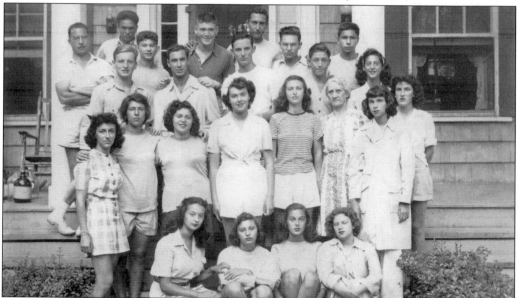

Jewish Fresh Air Camp was a meeting ground for Jewish youth from across the economic spectrum and from Central European and Eastern European subcommunities. Abe "Chief" Axelrod is shown with glasses on the left in the back. Mrs. "Standing Rock" Hill is on the right with white hair, and Sylvia Small, later a significant Jewish youth leader at Temple Beth Zion, is on the far left, both standing in the second row. (Courtesy of JCC Collection, University Archives.)

71

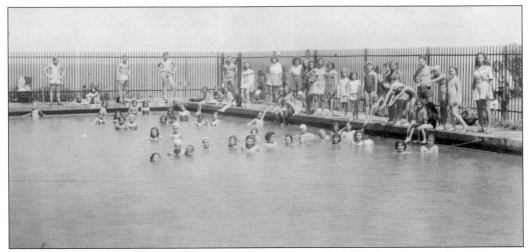

The Jewish Fresh Air Camp initially operated separate boys', girls', and mothers and babies' camps over the duration of the summer until the 1930s. Jewish summer camping eventually became less of an acculturation tool and more of a leisure experience for children and young adults, as this photograph at the pool demonstrates. (Courtesy of JCC Collection, University Archives.)

In 1947, the Jewish Fresh Air Camp was renamed Camp Lakeland. It remained in Angola, New York, for over a decade, but relocated to Franklinville, New York, in the 1960s. Camp Lakeland was also a training ground for future leaders drawn from the camp staff or counselors, who went on to make contributions in the Jewish and general communities. This is a photograph of the first group of Camp Lakeland counselors in 1947 in Angola. (Courtesy of JCC Collection, University Archives.)

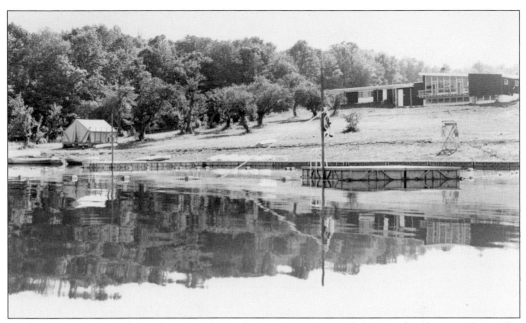

By the 1960s, Camp Lakeland in Angola was becoming increasingly less rural and more urban. The Camp Lakeland Association decided to buy a new site in rural Franklinville, New York. Ground was broken in the 1960s, and by 1973, the camp had relocated. This image shows the Joseph "Joe" House and the waterfront at Franklinville. (Courtesy of JCC Collection, University Archives.)

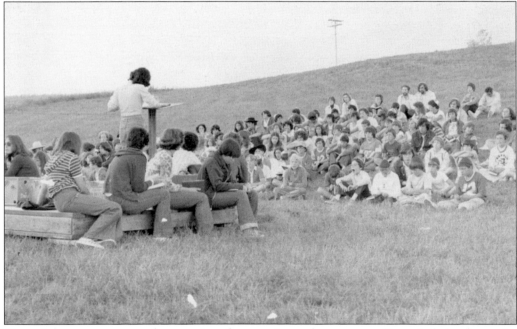

One of the many treasured memories of generations of campers at Camp Lakeland was the community Shabbat, when the entire camp gathered to sing at Friday night services. Camp Lakeland closed in 2009, having served the Jewish community as the overnight camp for thousands of Jewish youth over the years. Jewish overnight campers are now served by Camp Seneca Lake near Rochester. (Courtesy of JCC Collection, University Archives.)

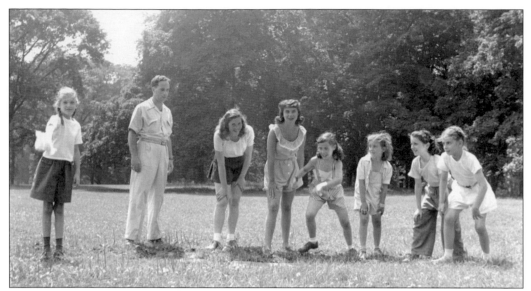

Camp Centerland, a Jewish summer day camping experience, began in the period following World War II, with a program of day camps in local parks, such as Beaver Island and Grand Island, pictured here with Getelle Rein, third from left. Jewish day camp experiences included outdoor activities, sports, field trips, crafts, and theater and music programs. (Courtesy of JCC Collection, University Archives.)

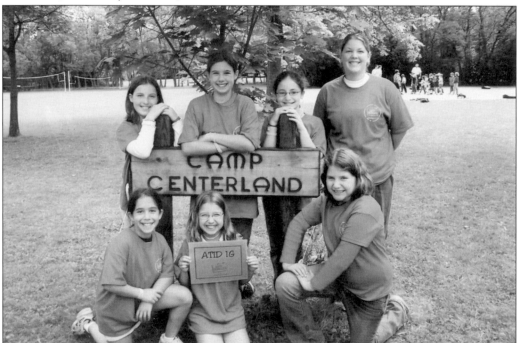

Camp Centerland opened its own facility in 1955 when the Jewish Community Center purchased a 78-acre tract of land in rural Elma, New York. The camp developed dramatically over the years. On Sundays, it opened free to the community, and many families would spend their day there during the summer. Generations remember taking "a creek walk." A new Camp Centerland opened in 2013 at the JCC in Getzville. (Courtesy of JCC Collection, University Archives.)

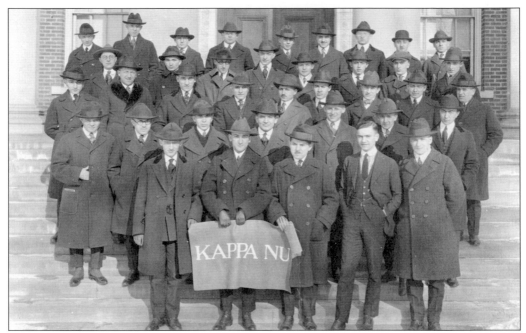

Kappa Nu was a Jewish fraternity at the University at Buffalo active during the 1910s and 1920s. It was not associated with any particular academic discipline but drew members from across the campus with a goal to build fraternity among other Jewish (male) students. This photograph dates from the 1910s. Abraham Carrel is in the back row, second from right. (Courtesy of Ellen Goldstein and Amy Goldstein.)

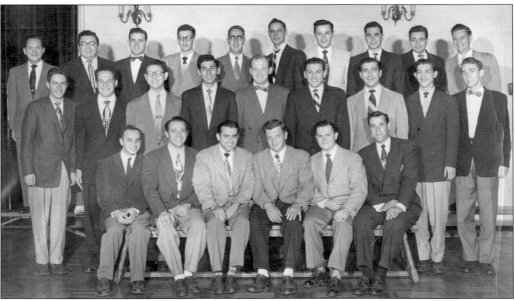

Several Jewish fraternities exist in Buffalo, including Maimonides for physicians. Rho Pi Phi (pictured) was the Jewish fraternity for pharmacy students that included student members from University at Buffalo and other surrounding schools. Included in the photograph are Harvey Schiller, Joe Sterman, Sonny Heller, Jerry Greenspan, Ron Silverberg, Sherman Wolman, Alan Sirkin, and Harry Kravitz. (Courtesy of Joyce Edelman Greenspan.)

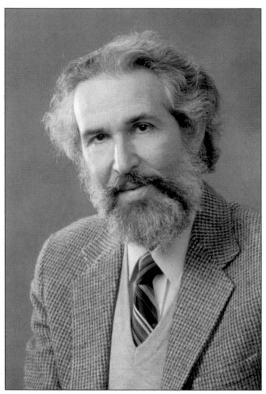

Hillel at Buffalo was founded in 1946 by Arthur I. Goldberg of the Montefiore Lodge No. 70, B'nai Brith, with the aid of the Jewish Federation of Greater Buffalo. Pictured is Rabbi Shay Mintz, former Hillel director, a *sabra* (native Israeli) and a former Jewish educator at several institutions including Temple Shaarey Zedek and the JCC. He was also the founder with his wife Lila of the People of the Book, an endowment that helps sustain the annual Jewish Book Fair. (Courtesy of Jewish Federation of Greater Buffalo.)

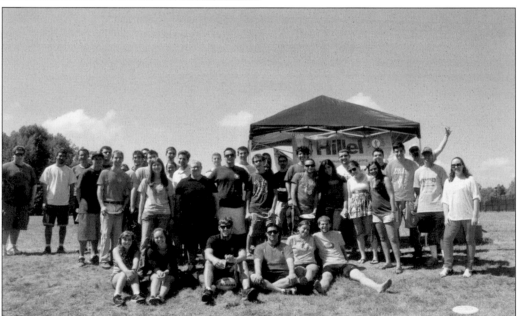

Hillel of Buffalo is undergoing a renewal at the University at Buffalo and is working closely with the Jewish Federation of Greater Buffalo and the new Institute for Jewish Thought and Heritage. It is also working with an array of other local Jewish organizations, including the High School of Jewish Studies, the Bureau of Jewish Education, Hillel Alumni, and local professionals and businesses. (Courtesy of Hillel of Buffalo.)

Four

FAMILY, SOCIAL, AND ORGANIZATIONAL LIFE

From the beginnings of Jewish life in Buffalo and Niagara Falls, the expansion of the community depended on new immigrants. Developing throughout the 19th century on the enormous success of the Erie Canal, Buffalo continued to need people as it grew into the 20th century, becoming the eighth largest city in America. Before the 1880s, Jews came in small numbers from Baden and Bavaria as well as parts of Lithuania and Poland. The mainly German-speaking Jews joined some existing German social and musical organizations and formed their own lodges and organizations and synagogue communities.

After the 1880s, however, the number of Jewish immigrants rose rapidly, and a Jewish population in 1875 that numbered just above 1,500 tripled within a decade, and this trend accelerated. While employment opportunities were initially limited because of competition and lack of language skills, Jewish immigrants adjusted by creating their own institutions. In the era before social service, one of the critical means of support was self-help. Eastern European Jewish immigrants utilized their hometown connections and formed mutual aid organizations that also served as social networks.

Through family links, friendships, mutual aid organizations, synagogue affiliations, and Zionist and Socialist organizations, Jews in Buffalo and Niagara Falls also gave support for particular causes. Movement into the suburbs after World War II, as a result of increasing economic security and affluence, further extended social and friendship networks.

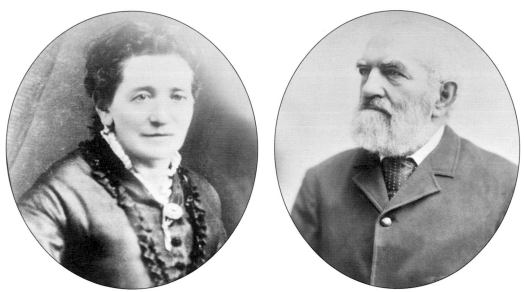

Emanuel Fleischmann was born on August 14, 1825, in Bavaria. Emanuel trained to be a Torah reader, Hebrew teacher, and *schochet* (ritual slaughterer). He came to Buffalo in the 1870s and, with his wife, Eliza (née Dessauer), had two children and was affiliated with Temple Beth Zion. His daughter Bianca wrote and published music, and son Simon was a prominent trial lawyer. Emanuel was an active Montefiore Lodge and Knights of Pythias member. (Courtesy of Peter Fleischmann.)

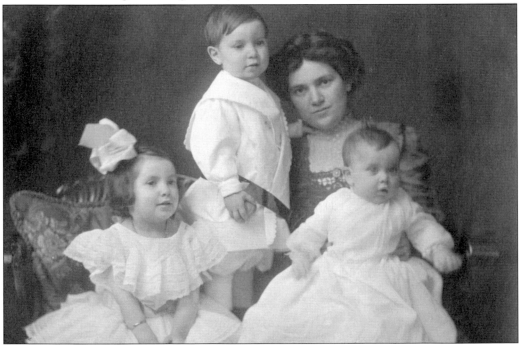

Lydia Meyer Block (third from left) came to Buffalo as a baby from Germany in 1883. From left to right are her children born in Buffalo: Miriam Block, Nathanial Block, and Charles Block. Lydia's fourth child, Marjorie Block (later Friedman) was born in 1914 after this portrait was taken, by which time Charles had died as a result of contracting the mumps. The Block family lived on Richmond Avenue on the West Side and were part of a German-Jewish elite. (Courtesy of Catherine Friedman Goldman.)

Annie Friedland Silverman, seated at left, was born in 1873 in Mir, Belarus, and came to the United States in the 1890s. Max Silverman (seated at right) was born in Lithuania and immigrated to England as a child and later settled in Buffalo. He worked as a tailor in the city. Annie and Max are shown with their children, all born in Buffalo, from left to right, Alfred (born 1907), Edith (born 1899), and Dorothy (born 1900). Alfred became a New York state assistant attorney general, and Edith a city court clerk. Dorothy worked as a chemist at the New York Department of Agriculture. (Courtesy of Bette Silverman Davidson.)

Pearl Sunshine, later Pearl Korus, is second from right, with Ida Sunshine (later Bearen). Pearl Sunshine came to Buffalo from Russia via Romania, to settle on the East Side on Hickory Street. There she lived in an extended household with grandparents Harry and Ida Sunshine. The name Sunshine in Buffalo is synonymous with Sunshine Markets. Pearl's uncle began the business, which was successful for many years. (Courtesy of Sam Korus.)

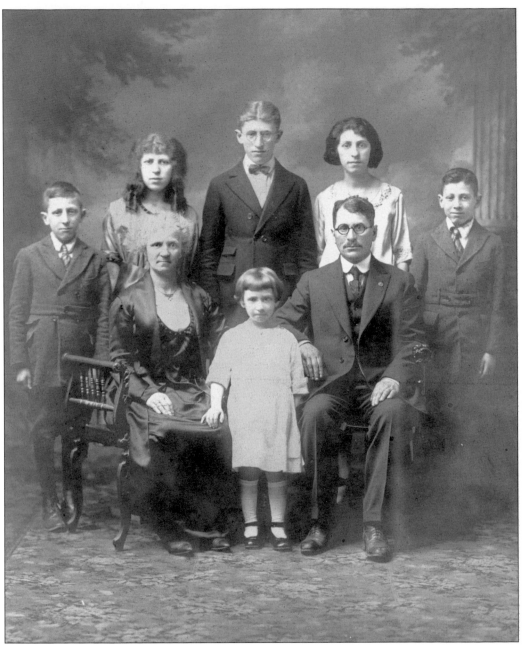

An immigrant from Ukraine, Max Fagin started his own business collecting secondhand bottles and washing and reselling them. Max became an early Hebrew Benevolent Loan Association member and aided other new immigrants in getting interest-free loans. This photograph, taken in 1905 before the family lost almost everything in the Great Depression, reveals early success. Eventually the family business was rebuilt, and continues today as EmpireEmco. The business has expanded into specialized glass and plastic container manufacturing. From left to right are (first row) Dora Fagin, Evelyn Fagin, and Max Fagin; (second row) Sam Fagin, Shirley Fagin, David Fagin, Lena Fagin, and Louis Fagin. (Courtesy of Susan Freed-Oestreicher.)

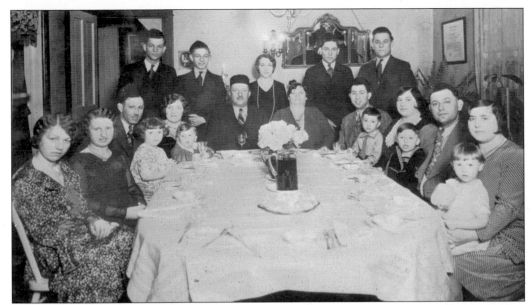

Shabbat, beginning Friday at sundown and ending soon after sundown on Saturday evening, begins with a Shabbat meal with the extended family and friends. This 1920s photograph shows the family matriarch and grandmother Rachel Benatovich Schrott, with her second husband, Pesach Schrott. Sam Benatovich is standing in the left corner. (Courtesy of Dr. Howard Benatovich.)

This photograph of a Passover Seder was taken at the Dimet family home in Niagara Falls. Simon Dimet served as president of Temple Beth Israel from 1938 to 1942. Under his term, a fund began to enlarge the temple's first home on Cedar Avenue. Ground breaking eventually began in 1947, and the work was completed in 1948. It added new classrooms, a stage, an updated kitchen, and a larger vestry room. (Courtesy of Temple Beth Israel Collection, Niagara Falls, University Archives.)

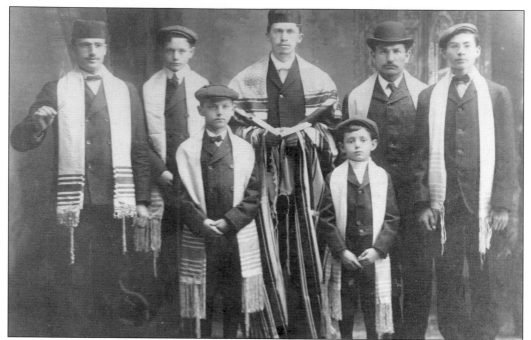

The smallest boy in this photograph is East Sider Hyman Arluck. Hyman later became the legendary Harold Arlen, known for his great American song compositions including "Get Happy," "Let's Fall in Love," and the Oscar-winning "Over the Rainbow" in *The Wizard of Oz*. Arlen's music is undergoing a resurgence with the musical *The Wonderful Wizard of Oz: The Music of Harold Arlen*. (Courtesy of Hugh Rubenstein Collection, University Archives.)

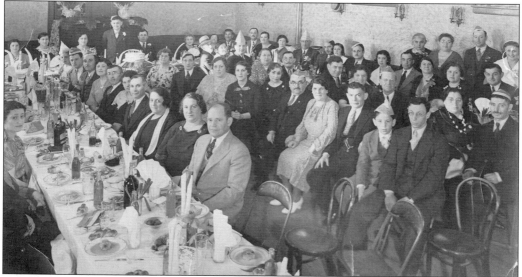

Harold Siegel, the bar mitzvah boy standing at far left, came from an East Side family. During the 1930s, bar mitzvah celebrations, attended by family and community members only, were more modest affairs, unlike their later celebrations that were heavily child centric. In addition, synagogues on the East Side, even Congregation Ahavas Sholem, one of the larger temples, did not have space to rent for such events, so local restaurants were rented instead. (Courtesy of Harold Seigel Collection, University Archives.)

Landsmanshaftn and synagogue meetings were often conducted in the Jewish Community Building at 406 Jefferson Avenue, as seen in this gathering of Pine Street Shul members in 1930. Front row, center right is Louis Bookbinder, grandfather of Harvey Schiller, and front row center left is Louis Freedman, grandfather of Nancy Freedman Schiller. (Courtesy of Nancy Freedman Schiller.)

A significant number of Polish Jews from the village of Nasielsk came to Buffalo, New York, in the 1920s. The name of the town in Yiddish was Nashelsk, and *landsleit* (hometown) members were known as Nashelkers. They gravitated to Ahavas Achim (also known as the Fillmore Shul). Leibisch Silverstein, a shochet, is in the third row. Arlene Richman is sitting on the floor. The Nashelsker community maintained social ties through annual conventions such as this one on September 1–3, 1951. (Courtesy of Joyce Edelman Greenspan.)

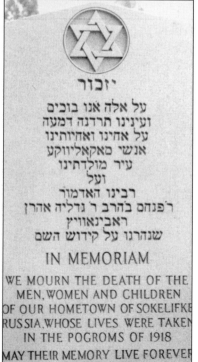

יזכּר

עַל אֵלֶּה אָנוּ בוֹכִים
וְעֵינֵינוּ תֵּרַדְנָה דִּמְעָה
עַל אַחֵינוּ וְאַחְיוֹתֵינוּ
אַנְשֵׁי סאָקאָליווקע
עִיר מוֹלַדְתֵּנוּ
וְעַל
רַבֵּנוּ הָאַדְמוֹר
ר' פִּנְחָס בְּהָרַב ר' גְּדַלְיָה אַהֲרֹן
ראַבִּינאָוויץ
שֶׁנֶּהֶרְגוּ עַל קִדּוּשׁ הַשֵּׁם

IN MEMORIAM

WE MOURN THE DEATH OF THE
MEN, WOMEN AND CHILDREN
OF OUR HOMETOWN OF SOKELIFKE
RUSSIA, WHOSE LIVES WERE TAKEN
IN THE POGROMS OF 1918
MAY THEIR MEMORY LIVE FOREVER

ERECTED BY THE SOKELIFKER
LANDSLEIT OF BUFFALO, N. Y.
DEDICATED AUGUST 30, 1964

Mutual benefit organizations were self-help societies that combined credit and sick and death benefits with social activities. One of the largest landsmanshaftn groups was the Ustingrader Unterstitzung Verein, a hometown group of Jews from Sokolivka between Kiev and Odessa. More information about this community is given in *The Shuman Story*, composed partly of the writings of Chaika Aliotz Shuman. Chaika is sitting in this photograph, second from right. Her husband, Peretz, is standing immediately behind her. Their children are also shown standing in the back row. Charles Shuman is at far right, Irving Shuman is second on the left, and Hyman is third from the left. (Courtesy of Charles Shuman.)

A memorial was erected by the Sokolivker landsleit of Buffalo, New York, and dedicated on August 30, 1964, at Pine Ridge Cemetery in Buffalo, to commemorate the lives that were taken in the pogroms of 1918. Parker Komm created this commissioned monument for the Sokolivker community. (Courtesy of Leon R. Komm.)

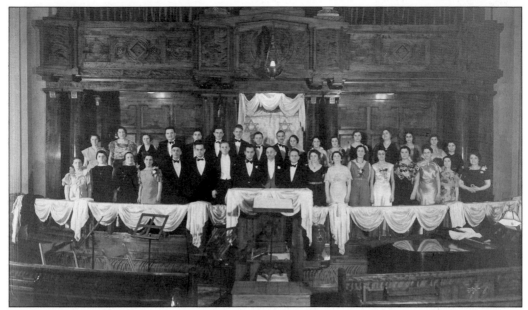

The Jewish Choral Society was organized in 1929 and was led by Samuel Luskin, Hebrew teacher at the Talmud Torah and Temple Beth El. He composed and published *Manginot Beth El*, a liturgical service. The choral society sang Hebrew liturgical music, Yiddish folk, and secular music. It was supported and sponsored by the Bureau of Jewish Education and met at Beth El and the Jewish Center. (Courtesy of Temple Beth El Collection, University Archives.)

Perseverance Lodge No. 948, a Masonic lodge, was originally founded as the "Abraham Lincoln Lodge" in 1917 but was renamed Perseverance soon after its founding. Within a decade it had over 200 members. The group rented accommodations until constructing its own purpose-built property in Amherst, which continues as its home base today. Louis Greenstein, prolific local architect, designed the lodge's insignia in 1918. (Courtesy of Sam Korus.)

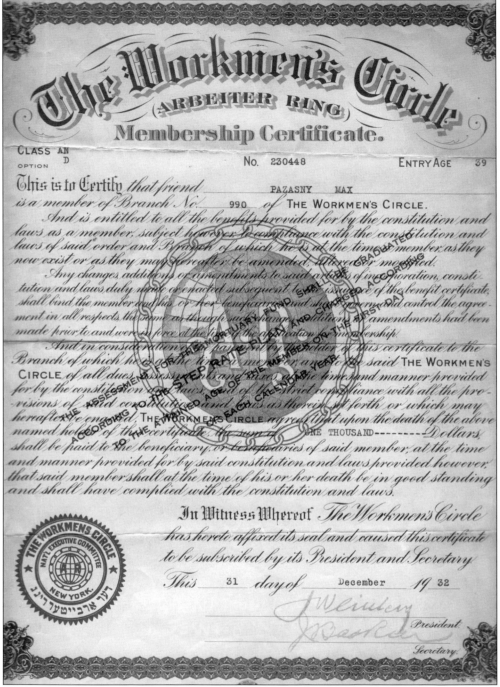

The Workmen's Circle
(ARBEITER RING)
Membership Certificate.

CLASS AN D
OPTION

No. 230448

ENTRY AGE 39

This is to Certify that friend ___PAZASNY MAX___
is a member of Branch No. ___990___ of THE WORKMEN'S CIRCLE.

And is entitled to all the benefits provided for by the constitution and laws as a member, subject however to compliance with the constitution and laws of said order and Branch of which he is at the time a member, as they now exist or as they may hereafter be amended, altered or modified.

Any changes, additions, or amendments to said articles of incorporation, constitution and laws duly made or enacted subsequent to the issuance of the benefit certificate, shall bind the member and his or her beneficiaries and shall govern and control the agreement in all respects, the same as though such changes, additions or amendments had been made prior to and were in force at the time of the application for membership.

And in consideration of the payment by the member holder of this certificate to the Branch of which he is at the time a member, and to the said THE WORKMEN'S CIRCLE of all dues, assessments and fixes at the times and manner provided for by the constitution and laws and of the strict compliance with all the provisions of said constitution and laws as therein set forth, or which may hereafter be enacted, THE WORKMEN'S CIRCLE agrees that upon the death of the above named holder of this certificate, the sum of ___ONE THOUSAND_____Dollars, shall be paid to the beneficiary, or beneficiaries of said member, at the time and manner provided for by said constitution and laws provided however, that said member shall at the time of his or her death be in good standing and shall have complied with the constitution and laws.

In Witness Whereof The Workmen's Circle has hereto affixed its seal and caused this certificate to be subscribed by its President and Secretary

This ___31___ day of ___December___ 19 ___32___

J. Weinber
President

J Basker
Secretary.

The Workmen's Circle was first founded in Buffalo in 1903 as the Arbeiter Ring, Branch No. 29, with Sol Kissin as secretary. By the late 1930s, there were four branches with a total membership of 205 men. There was also a youth circle, a ladies' branch, and the J.L. Peretz Shul, which met four afternoons a week and Sundays. As a self-help organization, the Workmen's Circle offered a credit union that also bestowed funeral benefits that helped families weather the Great Depression. Nathan Kavinoky was the official physician of the Arbeiter Ring. (Courtesy of Louis Pozarny.)

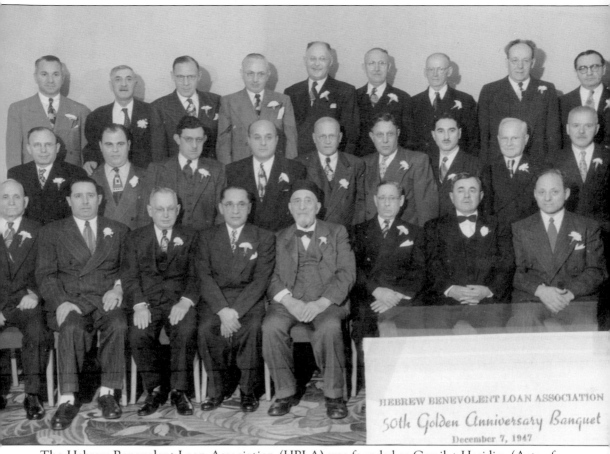

HEBREW BENEVOLENT LOAN ASSOCIATION
50th Golden Anniversary Banquet
December 7, 1947

The Hebrew Benevolent Loan Association (HBLA) was founded as Gemilut Hasidim (Acts of Loving Kindness) in 1897 in the home of Saul Rubenstein, shown at center with bowtie. This organization provided the means for businessmen who had some economic security to help others. For many on the East Side, the HBLA enabled them to escape poverty and, in later years, HBLA loans enabled students to study at college. The association continues to provide interest-free loans to those in need today. (Courtesy of Hebrew Benevolent Loan Association.)

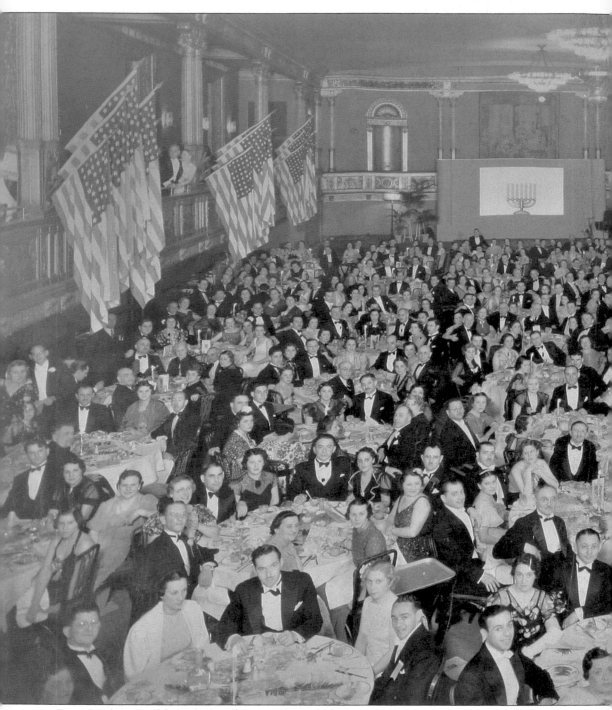

B'nai B'rith in Buffalo had a long history of various lodges with Montefiore as the founding group from the 1860s. During the 1940s, Balfour, Humanity, and Frontier Lodges were established. A women's auxiliary chapter began in 1922. During the 1930s, the Montefiore Lodge was extremely successful with membership drives under the leadership of Emil Rubenstein. Montefiore Lodge

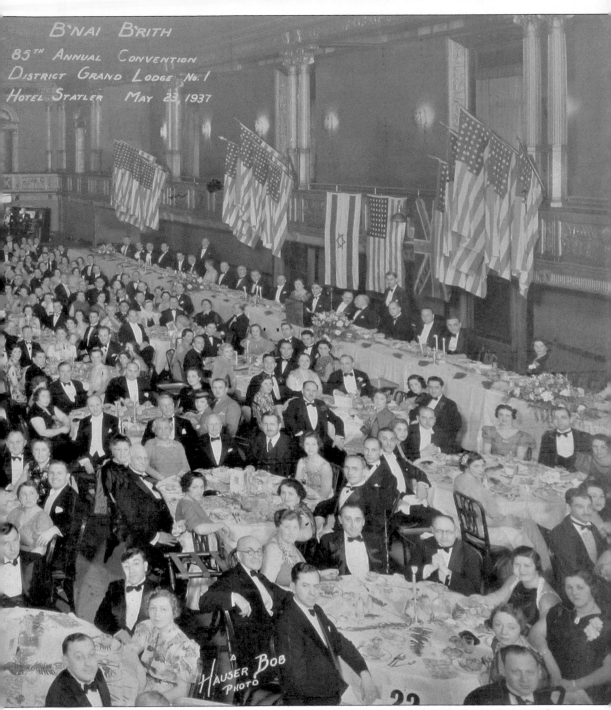

B'NAI B'RITH
85TH ANNUAL CONVENTION
DISTRICT GRAND LODGE No. 1
HOTEL STATLER MAY 23, 1937

HAUSER BOB PHOTO

No. 70 was the first organization in Buffalo during the 1880s to suggest the adoption of a citywide coordinated plan for assisting Eastern European immigrants. During the 1940s, Montefiore Lodge provided help in establishing the Hillel Foundation at the University at Buffalo. (Courtesy of JCC Collection, University Archives.)

On November 27, 1920, 29 women met to form a local branch of Hadassah. A month later, the chapter had a constitution and its first president, Ada Miller. By 1924, the group had 800 members. Over the years, a number of different chapters evolved, and fundraising activities involved social and cultural activities open to the entire community. Ada Miller is seated at front center in this 1962 image. Niagara Falls also maintained a separate chapter until 2013. (Courtesy of Jewish Federation of Greater Buffalo Collection, University Archives.)

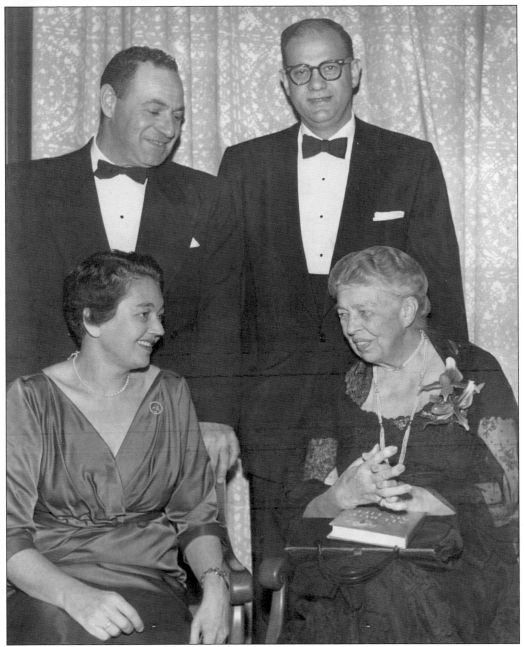

After the creation of the state of Israel in 1948, numerous Holocaust survivors and displaced persons, along with immigrants from numerous other countries, settled there. In order to raise the much-needed capital to fund absorption and security, David Ben-Gurion, Israel's first prime minister, with American Jewish leaders, launched the Israel Bonds movement in 1951. This Israel Bonds event at the Hotel Statler in 1952 includes guest speaker Eleanor Roosevelt on the right. At front left is Betty Stovroff. Standing are, from left to right, Jerry Brock and Sam Benatovich. (Courtesy of Dr. Howard Benatovich.)

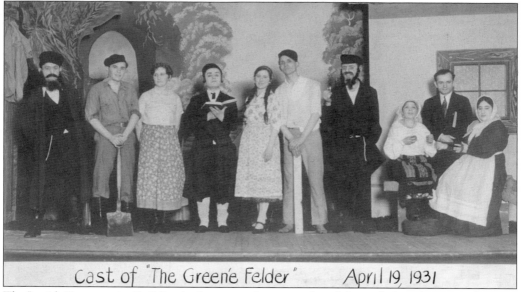

Cast of "The Greene Felder" April 19, 1931

The Jewish Community Building had a range of activities for adults, including drama productions such as *The Green Felder*. Many community plays either looked back to former homelands and the *shtetl* or had entirely universal themes. A professional theater, the Jewish Repertory Theatre is now housed in the newly refurbished suburban (Benderson) Jewish Center Building where performances are held year-round. (Courtesy of Jewish Federation of Greater Buffalo Collection, University Archives.)

Jewish drama groups, allied with the Jewish Community Center and synagogues, have always played a significant part in the Buffalo and Niagara Falls community. Many of the plays performed during the 1950s and 1960s would become American classics, including a number by Jewish immigrant Clifford Odets. This performance of *Golden Boy* featured Temple Beth Zion member Al Small, seen in character on the stage at far right. (Courtesy of the Small Family Collection, University Archives.)

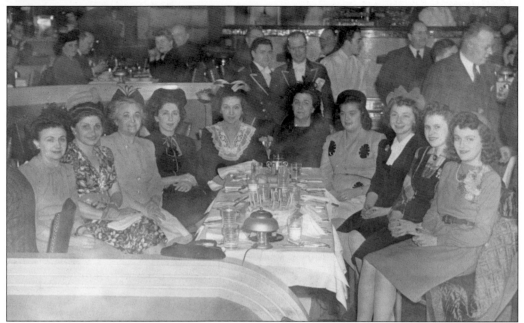

During the 1950s, Chez Ami on Delaware Avenue in Buffalo was a hotspot for friends to socialize and enjoy music and dancing. Chez had several complete makeovers, and old-timers remember the Art Deco interiors that were then replaced by a Venetian theme in the 1950s. Hilda Edelman, Ida Lazar, Chickie Lazar, and Janet Lazar are shown enjoying the ambience in this 1950s photograph. (Courtesy of Joyce Edelman Greenspan.)

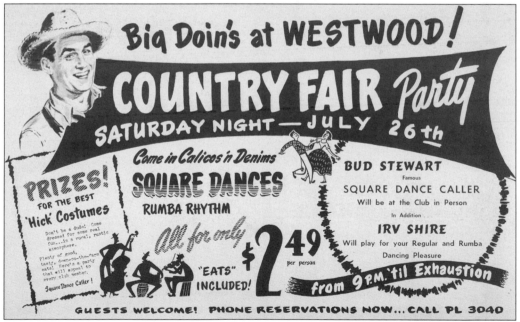

The Westwood Country Club or "The Westwood" is located in suburban Williamsville, New York, and was founded in 1945. Its roots lie in the Jewish country club Willowdale, which began operation in 1921 when Jews were generally excluded from country club membership. (Courtesy of Westwood Country Club Collection, University Archives.)

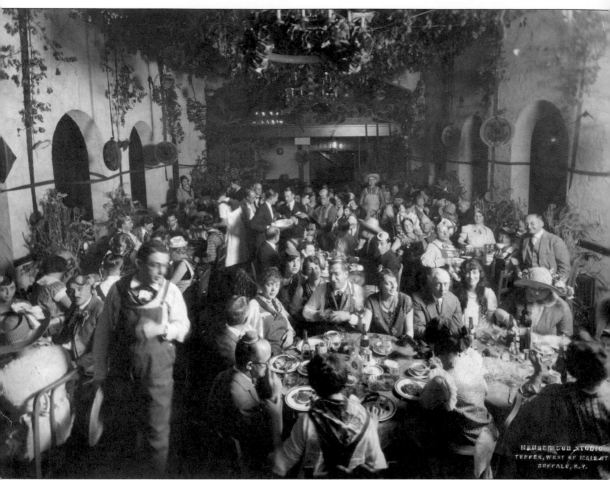

This photograph was taken in the 1920s at the Willowdale Country Club in Williamsville, New York. In 1929, because of failing revenues, the Willowdale merged with the Montefiore Club to form the Wilmont Country Club. It remained at the Williamsville location during the 1930s, but this union was short-lived and the Montefiore Club regained its independence by the 1940s, while the Willowdale closed. (Courtesy of Amy and Milton Zeckhauser Collection, University Archives.)

Five

CIVIC LIFE

Jewish community volunteers, supporters, and lay leaders played an essential role in the shaping of the contours of Jewish life in Buffalo and Niagara Falls. Volunteers formed the critical labor force of programs initially as well as funding the costs associated with programs. Early agencies, including the Jewish Federation and the Jewish Family Service, relied on their lay leaders for direction on policy as well as financial support. They also relied on professionals, such as doctors and dentists, to provide free services. Much later, as community organizations evolved and as Jewish civic life became the province of professionals, some day-to-day activities became professionalized, but the role of the volunteer remained a vital aspect of community agencies, especially in fundraising. Much of this activity, along with news of Jewish Buffalo, the region, and more, has been faithfully recorded in the pages of the *Buffalo Jewish Review* for almost 100 years.

Jews have also served the broader community through war service from the Civil War to World War I and World War II, Korea, and Vietnam. Holocaust commemoration and education have also become essential parts of Jewish remembrance for the devastating loss of millions of European Jews during World War II. Jews in Buffalo and Niagara Falls continue to invest themselves in both Jewish and broader civic, cultural, and educational organizations across the region.

FROM BUFFALO CITY HALL

Through Court Street to Broadway, continue one mile to Jefferson Avenue, turn right six hundred yards to

398 JEFFERSON AVENUE

Stop at the

Jewish

Welfare

Society

Headquarters for

RELIEF
WELFARE
HEALTH

It provides
Food for the hungry
Shelter for the homeless
Clothing for the cold
Care for the sick.

Through its staff of trained workers and its lay committee of Doctors, Lawyers, Merchants, Realtors, and other volunteers, it acts as Father, Mother, Big Brother, Big Sister, Doctor, Lawyer, Business Guide and Director. This corps of professional and volunteer advisors brings friendliness and encouragement, restoring men and women to normalcy and workers to industry.

Words alone cannot give a true picture of the vast amount of work done or the efficient and humane service rendered.

Jewish Family Service grew out of a number of different organizations but traces its beginnings to July 15, 1863, and the formation of the Hebrew Union Benevolent Society. In 1903, the Hebrew Union Benevolent Society merged into Federated Jewish Charities and was later renamed in 1916 the Jewish Federation for Social Service. In 1930, this agency reformulated as the Jewish Welfare Society. In 1947, the name changed again to Jewish Community Service Society. Today it is the Jewish Family Service of Buffalo and Erie County. (Courtesy of Jewish Federation of Greater Buffalo Collection, University Archives.)

Jewish Community Service Society News

Service Society Celebrates Century of Progress!

From a purely volunteer organization to help the poor and needy, the Jewish Community Service Society has undergone many changes in program and service through the years, giving up old activities as they were no longer needed and creating new services to meet changing needs.

Today the Jewish Community Service Society, though still governed by a board of 30 laymen elected by the Community, is manned by a group of highly trained professionals in the fields of family casework, child care, and vocational guidance and includes on the staff, a clinical psychologist and a part-time psychiatrist. Through this group of specialists, the agency is able to render vitally needed services to families in all walks of life who may need and want professional help with a personal or family problem — all geared to strengthen and preserve family life.

CECIL B. WIENER
"Miss Federation"

EUGENE WARNER
"Mr. Federation"

JOSEPH L. BROCK
JCSS President

Lawyer-judge-social worker-humanitarian—she was one of the first managers of the Jewish Welfare Society and later its president. Selflessly she has devoted her entire life to the needs of other people, and has made an indelible imprint on the Jewish Community Service Society.

Our first citizen . . . who sparked so many community efforts for two decades.

It was he who created the autonomous Jewish Welfare Society from a department of the Federation in 1930 . . . predicting and planning its future value to all citizens in all walks of life.

Joseph L. Brock, President of the Jewish Community Service Society reported today that the Society had just completed one of the most significant periods of its long history, during the term of office of his predecesser, Richard H. Wile. During that two-year period the Society:

1. Expanded its Vocational Service Department.
2. Embarked on a program to furnish to the aging, services which are not provided by other agencies.
3. Inaugurated its first family life discussion group.
4. Introduced a plan to acquaint members of the community with our services.
5. Organized an employment planning committee to facilitate placement.

Many other "firsts" were recorded during this period, and several service records were broken during 1955 —

1. 246 local families and 92 refugee families availed themselves of our family counseling and case work services.
2. 23 children were helped by placement in foster homes and special institutions, and through counseling and protective service.
3. 432 persons were aided by our Vocational Service Department in planning careers, finding jobs and adjusting themselves to their vocational abilities and limitations.

President Brock Lists JCSS Objectives For Coming Year

1. Development of services to the aging.
2. Exploration of the Society's role in the program set forth under the New York State Mental Health Service Act.
3. Extension of Family Life Education.
4. Reconsideration of the advisability of charging fees for any of its services.
5. Intensification of efforts and methods of informing the Jewish Community of Buffalo that the Society serves all its members, irrespective of social or economic status.

Program for Tonight!

Invocation	Dr. Joseph L. Fink
Greetings from the President	Joseph L. Brock
Film Presentation	"A Family Affair"
Speaker Of The Evening	Edward H. Kavinoky

The development of Jewish Social Service in Buffalo owes much to the founding work of Cecil B. Weiner. Cecil Weiner was one of the first managers of the Jewish Welfare Society and later its president. She trained as a lawyer in the 1890s and was one of the first two women to graduate at the University at Buffalo. She worked as a social worker before appointment as a judge. She wrote numerous reports in order to increase social welfare funding and was herself described as "the woman who can always add one more hour to the twenty-four" so that someone in need might benefit. (Courtesy of Jewish Family Service of Buffalo and Erie County.)

Jewish Family Service has benefited from several long-serving executives. This photograph, taken in 1982, includes several past presidents of the organization from 1952 to 1979, as well as Albert E. Deemer, executive director from 1953 to 1986. From right to left are Wayne Wisbaum, John M. Laping, Irving Fudeman, Hilda Koren, J. Milton Zeckhauser, Albert Deemer, Arnold Gardner, John Tabor, Haskell Stovroff, and Charles Sandler. (Courtesy of Jewish Family Service of Buffalo and Erie County.)

Jewish Family Service offers an array of services to the entire community including counseling, social work support, career development services, and refugee assistance. Pictured in the middle row at far right at the Israel Celebration Day march in 1998, marking the 50th anniversary of the founding of Israel, is the current executive director, Marlene Schillinger. Also pictured in the second row are (far left) Amy Stromberg and (middle) Toby Back. In the third row is Matthew Schillinger. (Courtesy of Jewish Family Service of Buffalo and Erie County.)

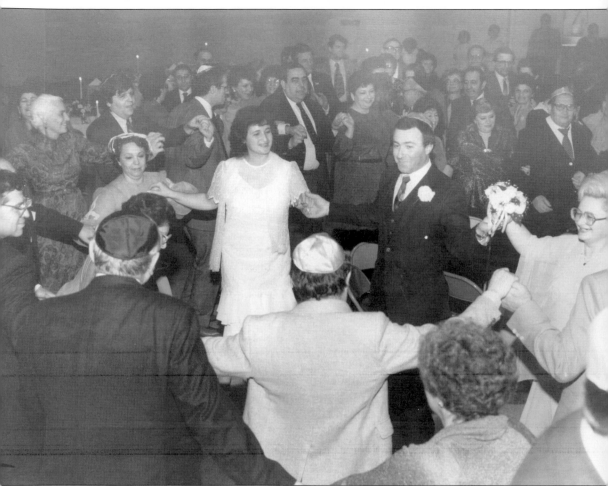

Jewish Family Service of Erie County was designated as the local resettlement agency in Western New York for Soviet Jews by the Hebrew Immigrant Aid Society (HIAS). This celebration for former *émigré* Russian Jewish couples took place at Temple Shaarey Zedek on December 18, 1983; Jewish Family Service and the Bureau of Jewish Education sponsored it jointly with Rabbis Shlomo Stern, Martin L. Goldberg, Steve Mason, and Joseph Herzog officiating. (Courtesy of Jewish Family Service of Buffalo and Erie County.)

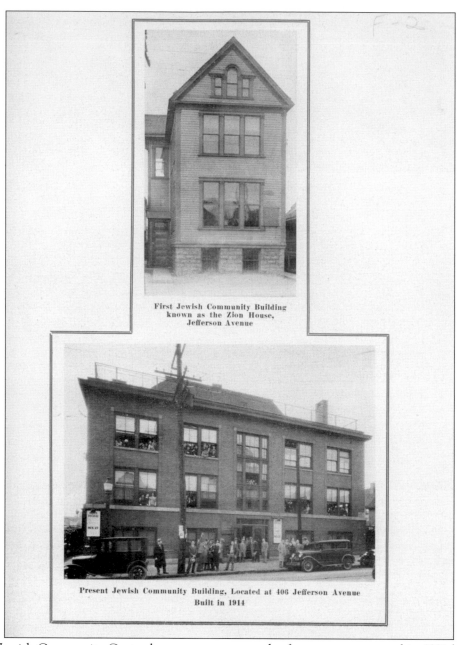

First Jewish Community Building
known as the Zion House,
Jefferson Avenue

Present Jewish Community Building, Located at 406 Jefferson Avenue
Built in 1914

The Jewish Community Center began as an outgrowth of a movement started in 1891 by the Sisterhood of Zion. The group initially rented a house on Walnut Street and then Spring Street until 1896, when a new building was purchased and called "Zion House" (top photograph). Within a decade, the space was too small, and fundraising led to the erection of the Jewish Community Building, on Jefferson Avenue (bottom photograph), which offered space for local hometown associations, mutual aid groups, and synagogues as well as an active program of scouting, arts, film, music, and theater until 1943. Most of all, activities were offered at little or no cost, and were accessible to the community. Temporary sites followed until the Jewish Community Center on Delaware Avenue was built. (Courtesy of Jewish Federation of Greater Buffalo Collection, University Archives.)

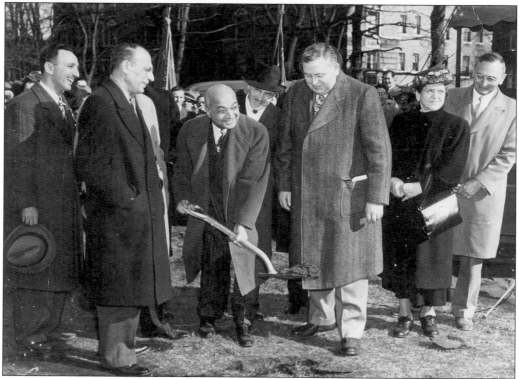

In 1945, Samuel Markel was the first president of the newly formed Jewish Community Center, which was a merger of the Jewish Community Building (constructed in 1914) and the Young Men's Hebrew Association (founded in 1921). He is pictured here with a shovel at the ground breaking ceremonies in 1948. To the right of Samuel Markel is the Hon. Bernard J. Dowd, mayor of Buffalo. Standing next to the mayor is Judge Cecil B. Weiner. (Courtesy of JCC Collection, University Archives.)

Hudson Valley painter Lewis Rubenstein, the inventor of "time painting," created this mural for the Jewish Community Center on Delaware Avenue in the front lobby. Rubenstein was a Buffalo native and part of the extended Rubenstein-Maisel-Setel family. (Courtesy of Foundation for Jewish Philanthropies, photograph by Don Dannecker.)

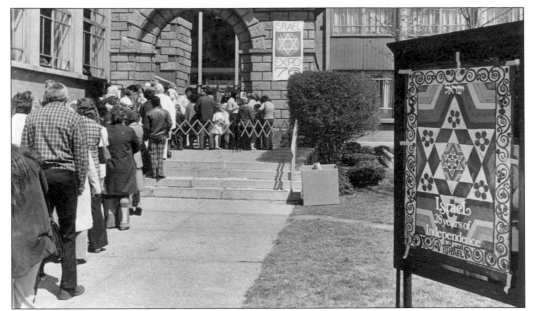

This photograph, taken in 1976 to celebrate 28 years of Israel Independence, shows some of the 4,000 visitors who came to visit the Israel Exposition held in May. "Expo76" was a community-wide effort to celebrate all things Israeli, from fashion, art, and culture to science and technology. It took two years to plan, utilized the services of over 1,000 volunteers, and set the model for other subsequent local ethnic holidays in Buffalo and beyond. (Courtesy of JCC Collection, University Archives.)

The Jewish Community Center runs numerous programs within its two facilities as well as community-wide commemorative and celebratory events. This photograph, featuring Israeli dancing at the Delaware Avenue site in Buffalo, marked Israeli Independence Day celebrations in 1970. Temple Beth Zion is also seen in the background. (Courtesy of JCC Collection, University Archives.)

The late Regina Holland, shown here with her daughter Ann Holland Cohn, was a steadfast supporter of the Jewish Community Center. She was an active volunteer for over 50 years at the Red Cross (even walking through the Blizzard of 1977) and many other institutions. Her bequest enabled the Delaware Avenue JCC to undergo essential renovations after a planned closure. Ann Holland Cohn continued her legacy as a long-serving volunteer and philanthropist and also held a number of presidencies herself at the Rosa Coplon Home, Jewish Federation, and the Foundation for Jewish Philanthropies. (Courtesy of Foundation for Jewish Philanthropies.)

By the 1960s, it was apparent to most of the Jewish community planners that the movement to the suburbs would likely accelerate, and the planning for a JCC in the suburbs began. This photograph shows the signing of the contract to build the Suburban Building. Standing are, from left to right, Sid Abzug, architect James Kideney, Maer Bunis, William L. Grossman, and William Kaufman. Sitting from left to right are Jewish Center president Gordon Gross, the building contractor, and Dr. Richard Ament. (Courtesy of Gordon Gross.)

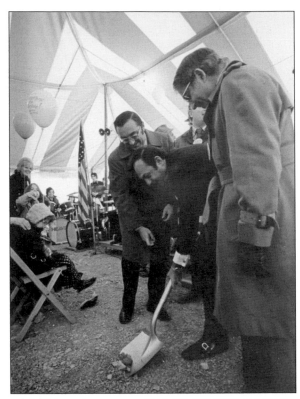

After five years of planning and significant fundraising, a ground breaking ceremony in suburban Getzville was held on October 15, 1972. Leonard Rochwarger, shown at far left, later became the ambassador to Fiji. Gordon Gross is holding the shovel, and Maer Bunis is on the right. The Suburban Building was later renamed the Benderson Family Building after a major gift from Nathan Benderson and his family. (Courtesy of JCC Collection, University Archives.)

This photograph of almost every past president of the Jewish Community Center (or family members of those deceased) was taken at the golden anniversary dinner celebrating 50 years. The event also honored charter members who in the mid-1940s went door-to-door in North Buffalo to solicit members for the newly forming Jewish Center of Buffalo. (Courtesy of JCC Collection, University Archives.)

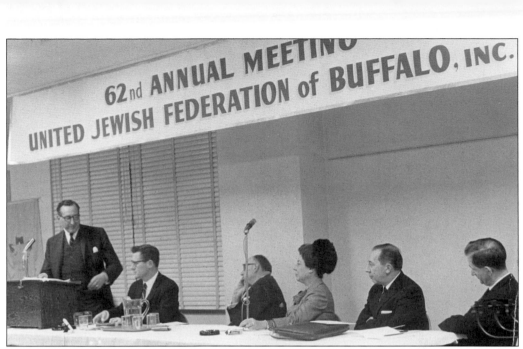

The Jewish Federation was originally founded in 1903 and has had various names over its history. Today, it is known as the Jewish Federation of Greater Buffalo and has a broad mission of bringing Jewish people together in Buffalo, providing support to Israel, and funding local Jewish organizations. The Jewish Federation also works to combat anti-Semitism and promote tolerance for both Jews and non-Jews all over the world. (Courtesy of Jewish Federation of Greater Buffalo Collection, University Archives.)

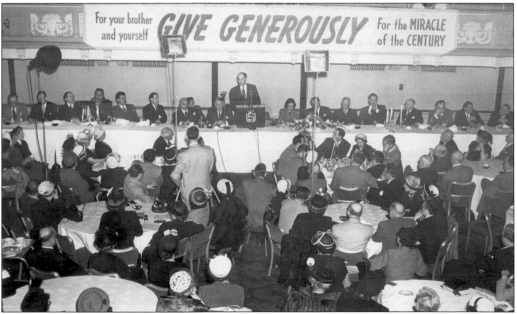

United Jewish Appeal for Refugees and Overseas Needs (UJA) was a national Jewish philanthropic umbrella organization originally created in 1939 that combined the efforts of three American Jewish aid entities. This postwar 1949 UJA fundraising event, held at the Hotel Statler in Buffalo, stressed support for the fledgling Israeli state. (Courtesy of Jewish Federation of Greater Buffalo.)

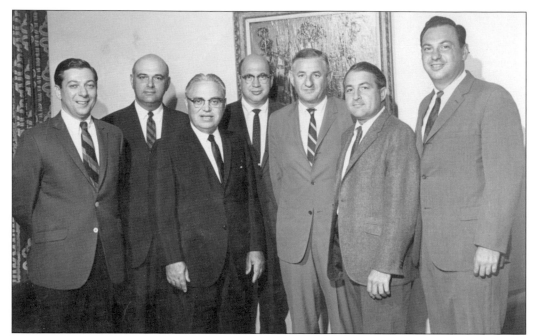

The Jewish Federation in Buffalo is arranged into men's and women's divisions as well as a series of committees and cabinets. This 1965 men's division photograph includes, from left to right, Charles Shuman, Harold Kirschenbaum, Sam Weinstein, Morris Markel, Samuel Lightman, Maer Bunis, and Gordon Gross. (Courtesy of JCC Collection, University Archives.)

In this 1970 photograph taken at a Jewish Federation dinner, contemporary and emerging leaders are seated together. Pictured are Joel Lippman, Nathan Benderson, Franklin Wisbaum, Leonard Frank, and Louis Bunis. Eugene Setel (on the far left of the second row) is the current president of the Holocaust Resource Center. (Courtesy of Jewish Federation of Greater Buffalo.)

Nathan Benderson began a real estate empire after World War II, growing it into one of the nation's largest privately held real estate businesses. Born in 1917, he saw his family lose their home on Fordham Drive during the Great Depression. He began his own business buying and selling bottles from local breweries at age 16 and started his first company, Niagara Dry Beverage Company, at age 21. Eventually he moved into property development, specializing in shopping centers, malls, office and industrial buildings, hotels, and residential complexes. He played a key role in the development of the Jewish Community Center in Getzville and the Weinberg Campus. As a generous philanthropist, he supported an array of causes, including those that helped the poor, the frail elderly, and animals, as well as numerous community organizations in Buffalo and nationwide, using a variety of special funds at the Foundation for Jewish Philanthropies. (Courtesy of Jewish Federation of Greater Buffalo Collection, University Archives.)

The Jewish Federation announces annually a fundraising drive that involves the entire Jewish community. Ruth Kahn, former president of a federally funded anti-poverty organization in Buffalo, is pictured with B. John Tutuska, the Erie County executive, and Nathan D. Rosen, businessman and philanthropist. At the time of this photograph in 1970, Ruth Kahn was the first woman to serve as president of the Jewish Federation. (Courtesy of Jewish Federation of Greater Buffalo.)

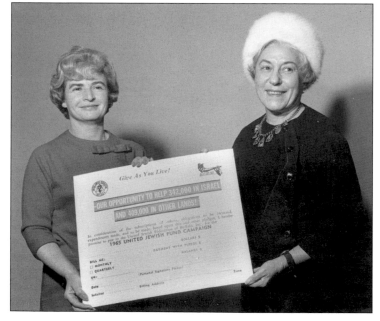

To help raise money, women of the Jewish Federation asked for donations from other women. This photograph shows Rose H. Frank (left) and Lillian Glaser, chairwomen of the women's division of the annual campaign, in 1964. Rose Frank was a tireless volunteer and encouraged hundreds of women to work for the campaign as part of "Rosie's girls." (Courtesy of Jewish Federation of Greater Buffalo.)

The UJF Women's Division campaign committee for 1975 included active community members in a range of other organizations as well as former presidents of the Jewish Community Center (Ethel Melzer, front row left) and the National Council of Jewish Women (Muriel Goodman, back row, second from right). Marilyn Shuman (front row center) has volunteered in numerous capacities and, with her husband, Irving Shuman, was later active in Sderot, "Project Renewal," a Federation program to develop the Israeli city. Gail Kaplan (back row left) later became a Jewish Federation president. (Courtesy of Jewish Federation of Greater Buffalo Collection, University Archives.)

Missions to Israel demonstrate the impacts of fundraising that the Jewish Federation carries out in support of Israel. Over the years, the missions have been led by members active in the Jewish Federation or community organizations. Howard and Lana Benatovich and Larry and Sharon Levite led this 1984 mission. (Courtesy of Jewish Federation of Greater Buffalo Collection, University Archives.)

Eugene Warner led the Jewish Federation from 1911 to 1913 and became president of the Foundation for Jewish Philanthropies "Sinking Fund" from 1919 to 1920 and from 1931 to 1944. Apart from these positions that gave leadership at critical moments for the Jewish community, he charted the separation of the Jewish Welfare Society from a department to its own agency and was a tireless worker for the benefit of the entire community. (Courtesy of Jewish Federation of Greater Buffalo Collection, University Archives.)

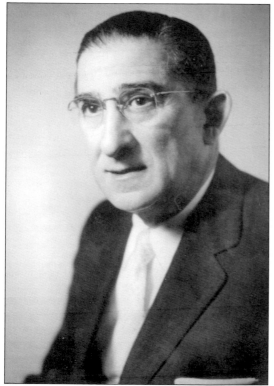

Stanley Falk, prominent attorney, was a leader in the Jewish Federation from the 1930s through the 1960s. Appointed Federation president in 1950, he was instrumental in establishing the German Refugee Committee of the Jewish Federation that later became the Buffalo Refugee Service, aiding over 500 Jewish refugees in Buffalo. From 1954 to 1965, Stanley Falk was president of the Foundation for Jewish Philanthropies. (Courtesy of Jewish Federation of Greater Buffalo Collection, University Archives.)

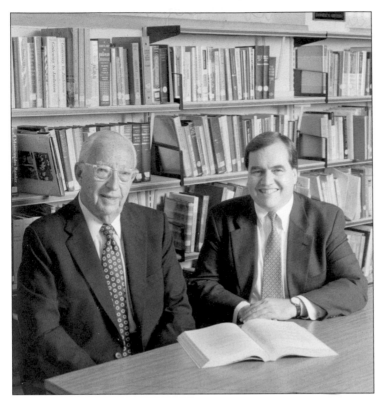

Haskell Stovroff (left) was a major philanthropist. He and his brother James Stovroff (not pictured) spearheaded the campaign to build the Stovroff Towers, part of Total Aging In Place, a managed long-term care plan. Through the Foundation for Jewish Philanthropies, they led funding for multiple community ventures. Peter Fleischmann (right) has served as director and chief executive officer of the Foundation for Jewish Philanthropies since 1982. (Courtesy of Foundation for Jewish Philanthropies.)

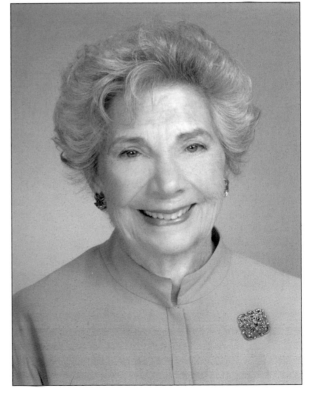

Ruth Kahn Stovroff has over the last seven decades volunteered for numerous nonprofit groups and has a record of many firsts. She was the first female president of the Jewish Federation of Greater Buffalo and again for the Foundation for Jewish Philanthropies. She was a president of Camp Lakeland Association, Olmsted Center for the Visually Impaired, and the Community Action Organization (CAO), among others. In 2005, she was inducted into the Western New York Women's Hall of Fame. (Courtesy of Foundation for Jewish Philanthropies.)

In 1910, west and East Side Jewish women, including Rosa Coplon (pictured), as the Daughters of Israel, worked to create a Jewish home for the elderly. In 1914, they purchased the first home, which soon filled to capacity. As a memorial to their mother, the three Coplon brothers, David, Joseph, and Philip, donated the George Walbridge Miller residence at 310 North Street on the corner of Symphony Circle. After remodeling, it opened in May 1924 with a new name, the Rosa Coplon Jewish Old Folks Home. (Courtesy of David and Minnie Coplon Family Collection, University Archives.)

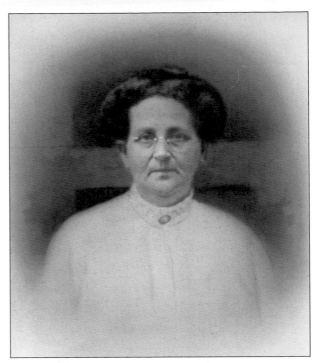

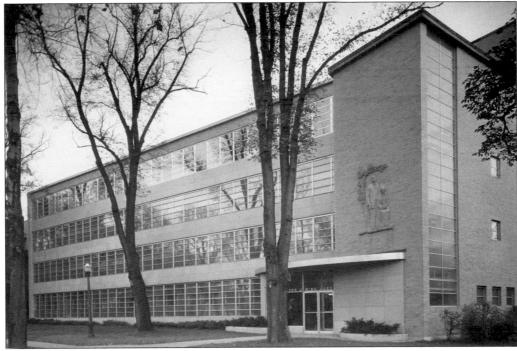

From the 1930s, the Rosa Coplon Jewish Old Folks Home expanded to include the infirm, frail, and chronically ill, not just the well aged. In the 1950s, after successive expansions at its Symphony Circle site, the home took another name to reflect its total role to the community, the Rosa Coplon Jewish Home and Infirmary. (Courtesy of David and Minnie Coplon Family Collection, University Archives.)

By the end of the 1980s, the Rosa Coplon site in the city was at capacity, and so over a decade, the Menorah Campus took shape. This new campus was to provide everything that an older adult would need. In 1993, the Rosa Coplon Jewish Home and Infirmary moved to Getzville. The campus was renamed the Harry and Jeannette Weinberg Campus in December 1994 with the Rosa Coplon Living Center as an independent unit within the facility. Weinberg Campus is at the cutting edge of elder care across the range of abilities and is seen as a model throughout the nation. (Courtesy of Foundation for Jewish Philanthropies, photograph by Don Dannecker.)

Jewish Federation Apartments is located at 275 Essjay Road in Amherst, New York, on a four-acre suburban site next to a supermarket, several shopping plazas, and medical facilities. Donald Day was president of the Jewish Federation when community leader Lou Jacobs, who owned the Sportservice Corporation (now part of Delaware North Companies), aided the housing project. Lou Jacobs provided the land for Essjay Road, and Donald Day spearheaded the fundraising campaign. The complex opened in 1979. (Courtesy of Foundation for Jewish Philanthropies, photograph by Don Dannecker.)

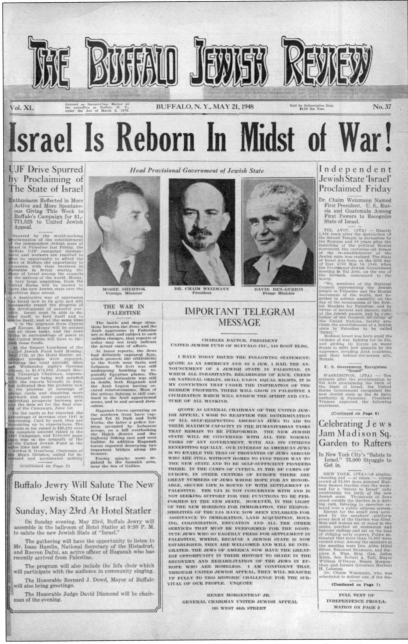

Originally founded in 1917 as the *American Jewish Review*, a few years later, the paper was bought by Elias Rex Jacobs and his wife Ida and became the *Buffalo Jewish Review*. On Jacobs's death, Arnold Weiss took over, and from 1980 he and his family have run the paper for nearly 35 years. In 2009, the entire run of back issues were donated by Rita Weiss and her family to the Jewish Buffalo Archives Project and are now available for research at the University Archives. This paper provides one of the most significant sources of historical information about the Jewish community over almost 100 years as well as world Jewish affairs, including the issue pictured here, which broke the news of the establishment of the state of Israel in 1948 and the Buffalo Jewish community's response. (Courtesy of Buffalo Jewish Review Collection, University Archives.)

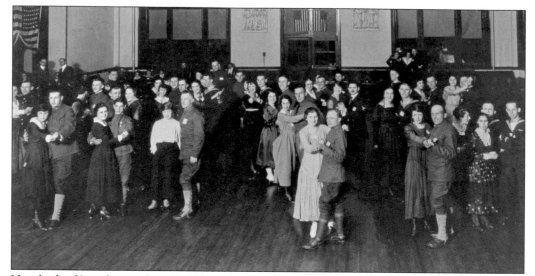

Hundreds of Jewish men from Buffalo served during World War I. At various times, Temple Beth Zion hosted dances for servicemen in the basement of the temple, as this photograph shows. A plaque in Temple Beth Zion displayed the names of 51 members who served. Soldiers served in the 309th Infantry of the 78th Division, 501st Engineers, 302nd Engineers, the Marine Corps, and the 305th Machine Gun Battalion of the 77th Division, among many others. (Courtesy of Cofeld Judaic Museum, Temple Beth Zion.)

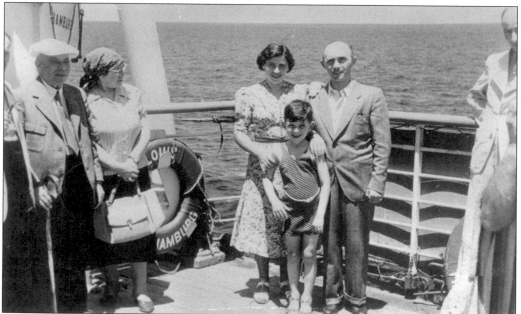

In the run-up to World War II and the Holocaust, thousands of Jews fled Nazi Germany, Austria, and Czech Sudetenland. On May 27, 1939, Sol Messinger, pictured at age six with his parents, was on board the SS *St. Louis.* The ship tried to dock in Havana with over 900 refugees, but was refused entry and was then turned away from the United States. It eventually returned to Europe. Messinger and his parents disembarked in Belgium, then fled to France and survived until 1942, when they entered the United States to stay. Sol Messinger eventually became a pathologist at Millard Fillmore Hospital and is a supporter of many local organizations. (Courtesy of Dr. Sol Messinger.)

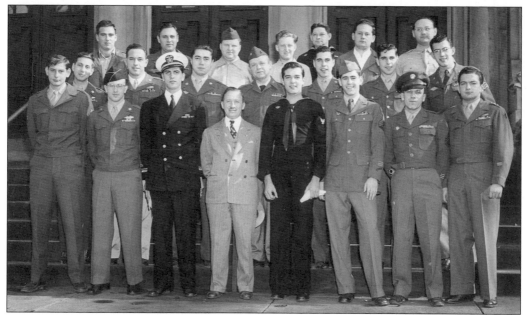

Many Jewish men (and women) served during World War II across the different branches of the military. This photograph, taken in 1943, shows a group of servicemen (and Beth El members) about to depart for service. Many of the men had distant relatives in Europe and knew of Nazi treatment toward Jews; however, in 1943, the full horrors of the Holocaust were not fully understood. Several rabbis also left their congregations in order to serve as military chaplains, including Rabbi Rickel of Beth El. (Courtesy of Temple Beth El Collection, University Archives.)

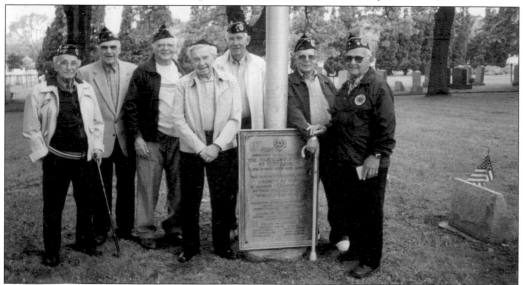

Sol Freedman established Louis Marshall Post No. 25, the first Buffalo-based veterans association, in 1927 for World War I veterans. In 1935, the group established its own cemetery plot in the Beth El Cemetery at Pine Hill (pictured). Over 2,180 Jewish men and women in Buffalo served during World War II, and as a result in the postwar period, two separate posts existed. They merged in 1950 to form Buffalo Frontier Post No. 25 Jewish War Veterans and remain an active organization. (Courtesy of Maurice Sands Collection, University Archives.)

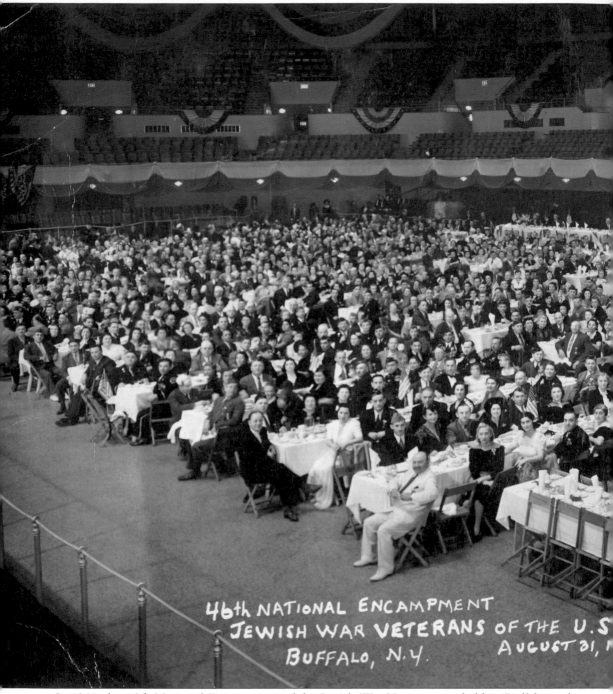

46th NATIONAL ENCAMPMENT
JEWISH WAR VETERANS OF THE U.S
BUFFALO, N.Y. AUGUST 31, 1

In 1941, the 46th National Encampment of the Jewish War Veterans was held in Buffalo, and Buffalo native Benjamin Kaufman, a World War I Congressional Medal of Honor recipient, was elected a national commander of the organization. This photograph was taken in the Memorial

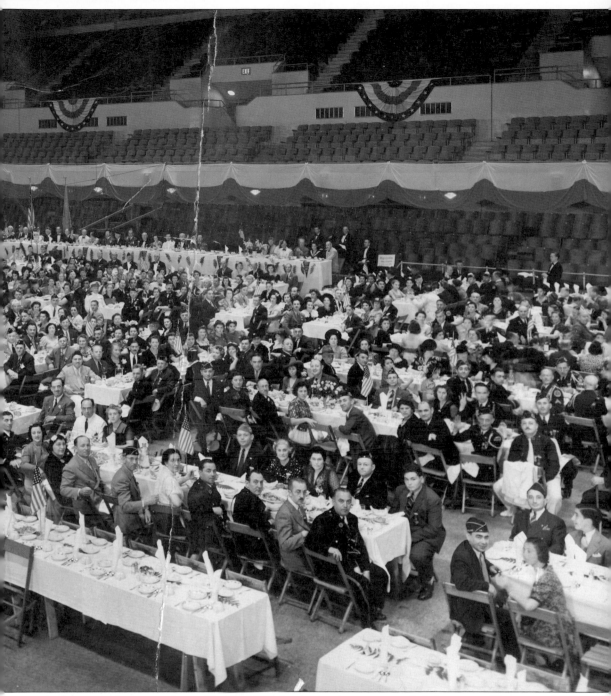

Auditorium, since torn down. Nearly 1,000 former servicemen attended the event. (Courtesy of JCC Collection, University Archives.)

In 1977, the community, through a committee headed by Morris Mesch and cochaired by Rubin Literman, hired sculptor Tony Rosenthal to create a Holocaust Memorial for Buffalo. Created in the shape of large interlocking metal pages, the memorial included the names of concentration camps and the words "Let us not forget" in both English and Hebrew. This memorial was dedicated at the Jewish Community Center in Getzville, New York, in 1977 at a public ceremony. Photographed are survivor Morris Glina with granddaughter Naomi. (Courtesy of Morris Mesch Collection, University Archives, photograph by Mickey Osterreicher.)

Annually, a community commemoration of those murdered during the Holocaust is marked throughout the community. In this 1983 photograph, commemorations began in the office of Mayor Jimmy Griffin and were attended by representatives from across the community including Rabbi Shay Mintz, Michael Hyman, Ruben Literman, and Toby Back. Rubin Literman, a Holocaust survivor, and Toby Back were moving forces behind the founding of the Holocaust Resource Center. (Courtesy of JCC Collection, University Archives.)

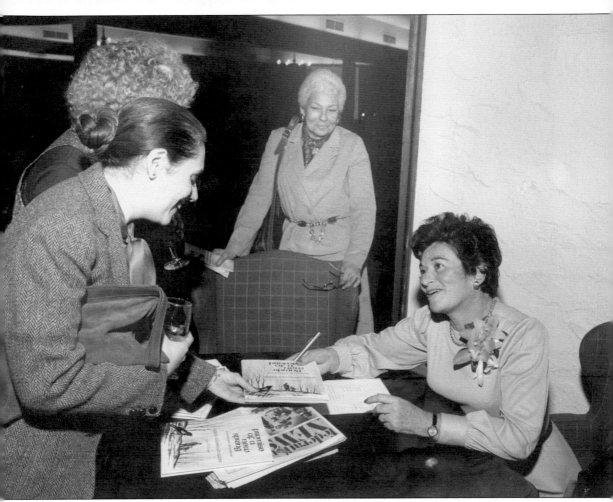

Gerda Weissmann Klein came to prominence as a writer and speaker after the publication of her critically acclaimed autobiography *All But My Life*, which chronicled her experiences during the Holocaust and her liberation by American troops, one of whom she would later marry, Kurt Klein of Buffalo. Over the decades, she has emerged as a spokesperson and advocate of tolerance, reconciliation, and dialogue and, in 2010, was awarded the highest civilian honor when she received the Medal of Freedom, conferred by President Obama. (Courtesy of Jewish Federation of Greater Buffalo.)

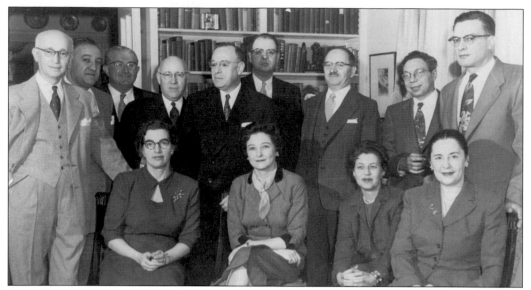

In 1954, a group of Jewish community leaders including Dr. Joseph Manch (superintendent of Buffalo schools), Louis Bunis, Morris Tabor, Edward Kavinoky, and the Hon. Judge Philip Halpern came together in order to organize the American Jewish Tercentenary Executive Committee, which created a series of events in Buffalo to mark 300 years of Jewish settlement in America. Dr. Selig Adler, also pictured, would write the seminal work of Buffalo Jewish history that was published in 1960 as *From Ararat to Suburbia*. (Courtesy of Jewish Federation of Greater Buffalo Collection, University Archives.)

In 1929, after conducting a house-to-house canvass throughout the city of Buffalo, Herman Wile, president of Temple Beth Zion, noted that large numbers of Jewish children had no access to Jewish education. A separate, but contemporaneous, survey of Jewish communal life recommended the establishment of a bureau of Jewish education in Buffalo to coordinate Jewish education. The Bureau of Jewish Education (BJE) was founded in the fall of 1929 with Herman Wile as first president, pictured at center. (Courtesy of Jewish Federation of Greater Buffalo Collection, University Archives.)

During the 1990s, "Summer of a Lifetime" trips to Israel enabled teens to travel and live in Israel for a six-week program. This was funded by grants from the Wolk Foundation and the Foundation for Jewish Philanthropies Israel Scholarships. The program fostered deep connections with Israel and lasting friendships among participants. (Courtesy of the Bureau of Jewish Education.)

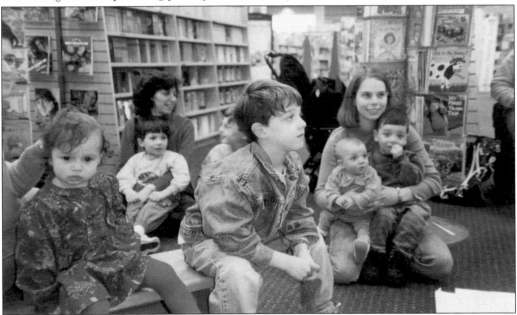

The Bureau of Jewish Education organizes programs across all ages and abilities from early childhood to adult education programs and, more recently, has included a special community-wide inclusion program through Yad b'Yad (hand in hand). This photograph features a past initiative, "Making Reading Time Jewish Time," at a local book chain before Passover. In 2013, the Bureau of Jewish Education, with funding through the Jewish Federation of Greater Buffalo, launched the PJ library service to provide free, age-appropriate Jewish-content books to Jewish children. (Courtesy of the Bureau of Jewish Education.)

The Jewish Civics Initiative (JCI) class has been offered at the Bureau of Jewish Education for over 20 years to students in grade 11. Studying Jewish values in relation to how to make the world a better place, the course culminates with a four-day conference in Washington, DC. While there, students work with a homeless program and study issues and policy as they relate to the values they have learned. Initially the fruits of a joint initiative of the JCC, BJE, and Temple Beth Am, in 1996, the BJE became the sole agency to run the JCI class. Pictured in a class from 1997 is Congressman Jack Quinn and aide Seth Gelber, Cantor Mark Horowitz (BJE executive director in 1997), Sue Brown (teacher), and Evie Weinstein. (Courtesy of the Bureau of Jewish Education.)

From 2011 to 2012, several Jewish agencies of the Greater Buffalo Jewish community relocated from various sites in Buffalo to a central campus at 2640 North Forest Road in Getzville, New York, in the newly refurbished and redesigned Jewish Community Center. The campus brings the Jewish Federation for Greater Buffalo, the Foundation for Jewish Philanthropies, and the Bureau of Jewish Education within the Jewish Community Center and provides a "central address" from which to create community-wide planning. The Weinberg Campus and University at Buffalo North Campus are both immediately adjacent, and the JCC also houses a new café, art gallery, theater, pool, and sporting facilities alongside outdoor recreational areas and Centerland, the Jewish community day camp. (Courtesy of Foundation for Jewish Philanthropies, photograph by Don Dannecker.)

BIBLIOGRAPHY

Adler, Selig, and Thomas Edmund Connolly. *From Ararat to Suburbia: The History of the Jewish Community of Buffalo.* Philadelphia, PA: Jewish Publication Society of America, 1960.

Berghash, Robert, ed. *A Photographic Journey, Fifty Years, The History of the Jewish Community Center of Greater Buffalo, Inc., 1945–1995.* Buffalo, NY: Jewish Community Center of Greater Buffalo, 1995. *Buffalo Jewish Review.*

Fischman, Jane Vogel. "Buffalo's Jewish Enterprise." *Western New York Heritage Magazine*, vol. 7, no. 4, winter 2005.

Fleischmann, Ilene R. *The Rosa Coplon Home Story, 1910–1985.* Buffalo, NY: Partner's Press, 1985.

Gellman, Jack A. *100th Birthday Celebration 1898–1998, Temple Beth Israel, September 13, 1998.* Niagara Falls, NY: Temple Beth Israel, 1998.

Goldman, Mark. *City On The Edge: Buffalo, New York, 1900–Present.* Buffalo, NY: Prometheus Books, 2007.

Graebner, William. *Coming of Age in Buffalo: Youth and Authority in the Postwar Era.* Philadelphia, PA: Temple University Press, 1990.

Hirsch, Dick. *The Bubble Didn't Burst: The Story of Nathan Benderson.* Buffalo, NY: Stonecroft Pub., 1995.

Hirsch, Dick, ed. *A History of Jewish Family Service in Buffalo 1847–1986.* Buffalo, NY: Jewish Family Service of Greater Buffalo and Erie County, 1986.

Jewish Community Archives, University Archives, SUNY at Buffalo

Mittleman, Ferne E., Hyman Shuman, and Chaika Aliotz Shuman. *The Shuman Story: The Life and Times of Peretz Shuman and Chaika Aliotz Shuman.* Amherst, NY: Welcome Magazine, 2000.

Rizzo, Michael F. *Nine Nine Eight: The Glory Days of Buffalo Shopping.* Morrisville, NC: Lulu, 2007.

Scrivani, Maria. *Brighter Buffalo: Renewing a City: History and Architecture.* Buffalo, NY: Western New York Wares, 2009.

ABOUT THE ORGANIZATION

The Jewish Buffalo Archives Project is a Jewish community-university partnership with the University Archives, University at Buffalo, under the auspices of the Bureau of Jewish Education and the Foundation for Jewish Philanthropies. With a mission to collect and preserve documentation relating to the diverse histories, religious traditions, and cultures of Jewish communities within the Greater Buffalo and Niagara area of Western New York, the Jewish Buffalo Archives Project partners with the University Archives, University at Buffalo, to make this material accessible to researchers and the general public. Since its inception, much of the work of the Jewish Buffalo Archives Project has been supported by the generosity of funders through the Foundation for Jewish Philanthropies. Funding has also been received through the Documentary Heritage Program of the New York State Archives. More about the project is available at http://library.buffalo.edu/archives/jbap/. A digital collection can be accessed via http://nyheritage.org/collections/jewish-buffalo-image-collection. Readers can also contact the author with comments through her own website at www.chanakotzin.org.

Discover Thousands of Local History Books
Featuring Millions of Vintage Images

Arcadia Publishing, the leading local history publisher in the United States, is committed to making history accessible and meaningful through publishing books that celebrate and preserve the heritage of America's people and places.

Find more books like this at
www.arcadiapublishing.com

Search for your hometown history, your old stomping grounds, and even your favorite sports team.